Japanese Clip Art for Machine Embroidery

By Alan Weller.
Designed by Kerri Lakatos.

The CD-ROM file names correspond to the images in the book. All of the artwork stored on the CD-ROM can be imported directly into a wide range of design and word-processing programs on either Windows or Macintosh platforms. No further installation is necessary.

ISBN-13: 978-0-486-99129-0
ISBN-10: 0-486-99129-6

Manufactured in the United States by Courier Corporation
99129601
www.doverpublications.com

Japanese Clip Art for Machine Embroidery

DOVER PUBLICATIONS, INC. | Mineola, New York

Japanese Clip Art for Machine Embroidery

In this book you will find a collection of rare, authentic Japanese designs. These images have been carefully chosen, cleaned and prepped to give you the best quality images to use with your electronic embroidery design-making software. This unique publication helps you skip the time-consuming scanning and cleaning of images, and let's you jump right to the fun part—pattern making and sewing out!

What's in the book:

The black-and-white version shows the file that you can use in your design-making program, to create the sewable pattern.

The book is a visual index of all of the files that are on the accompanying CD. In the upper left or right hand corner of each index page is the image number that corresponds to the equivalent file on the CD.

On every index page there are three different color ideas for each design.

Next to each color idea is a list of the colors that are used in the design. The number refers to the Isacord thread color number.

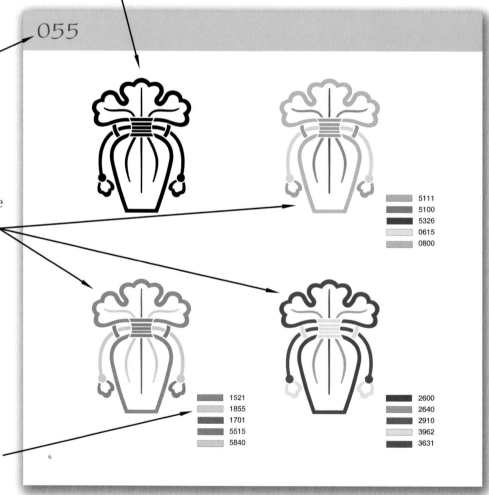

On pages 108-110 of this book you will find a thread conversion chart, which helps you choose the appropriate thread color from four different manufacturers.

What's on the CD:

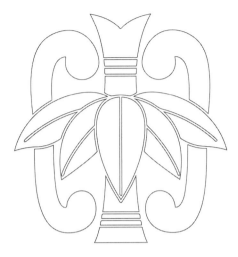

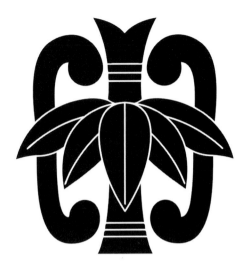

The outline versions of the images can be used with many design-making programs to create sewable patterns. Consult your program's instruction manual for specific instructions. There are both JPG and vector versions of these images on the CD.

The mass versions of the images can be used with most design-making programs to create sewable patterns. There are JPG and vector versions on the CD.

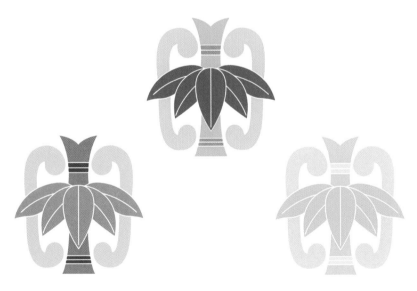

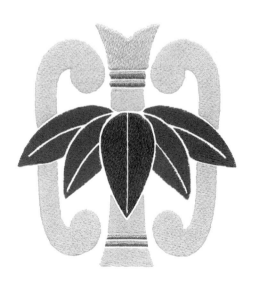

There are three color versions of each design on the CD. In addition to using them as a source for color ideas, these JPG images can be used as clip art for any crafts or graphics project. These files are located in the "Color JPG" folder.

A finished, sewn-out pattern that was made using Brother's PE Design® software program, and Dover clip art.

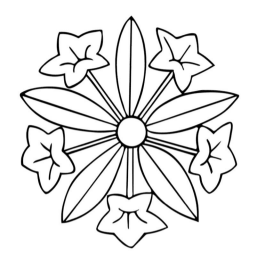

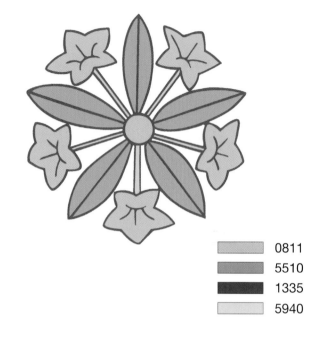

	0811
	5510
	1335
	5940

	2560
	5210
	0900
	5611

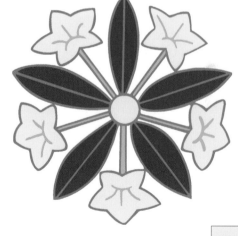

	0706
	5411
	5326
	4121

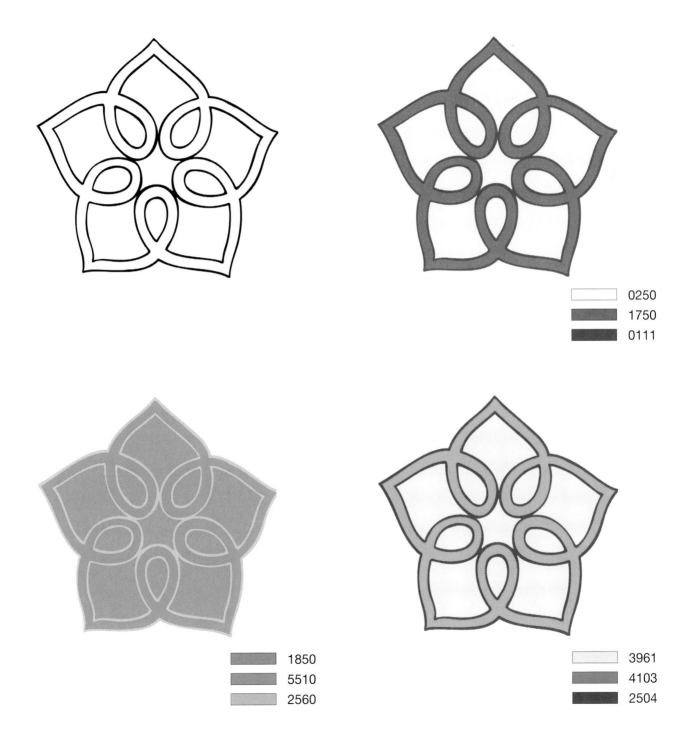

0250
1750
0111

1850
5510
2560

3961
4103
2504

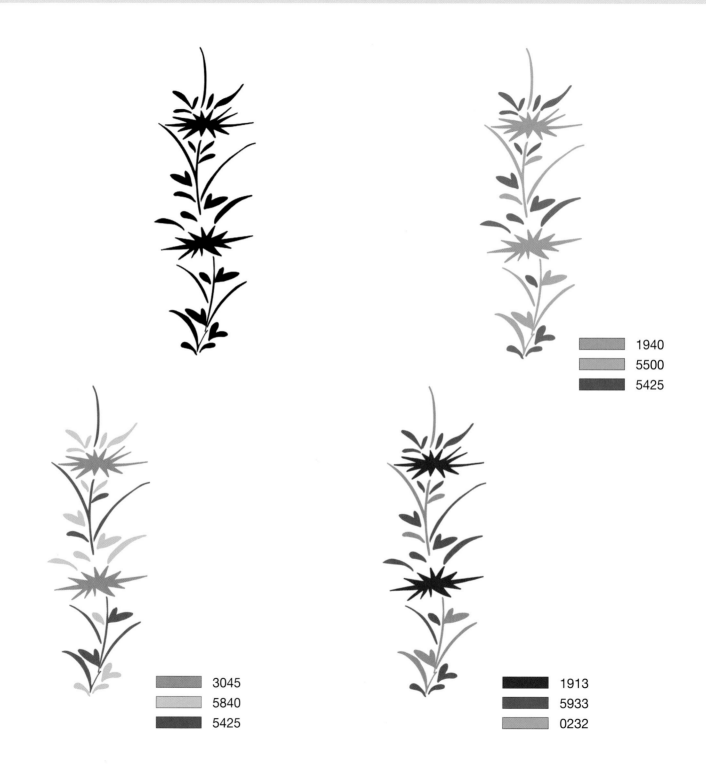

1940
5500
5425

3045
5840
5425

1913
5933
0232

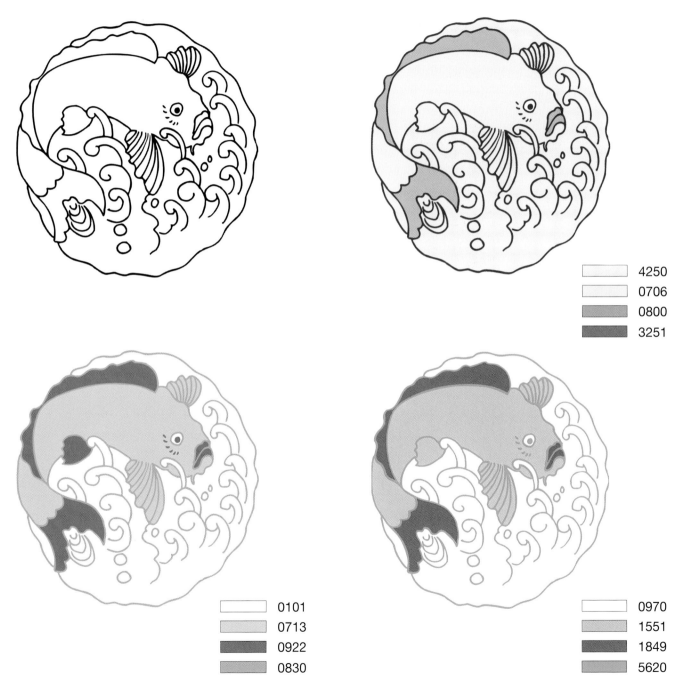

	4250
	0706
	0800
	3251

	0101
	0713
	0922
	0830

	0970
	1551
	1849
	5620

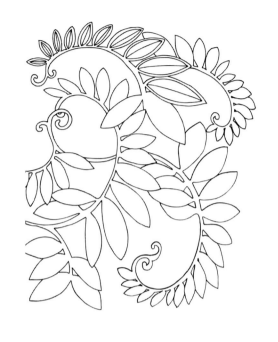

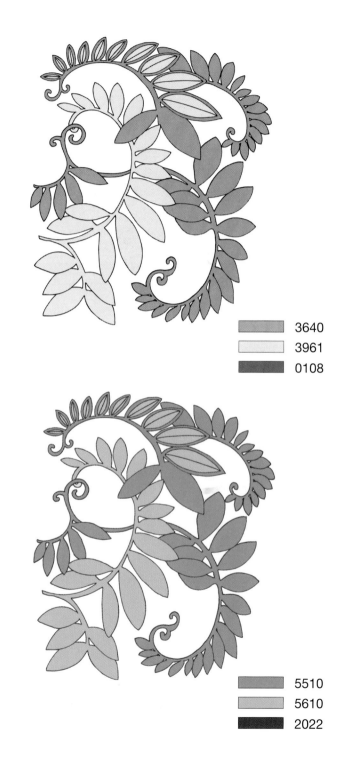

	3640
	3961
	0108

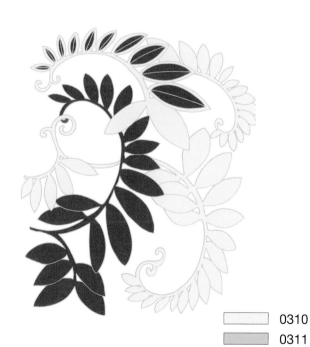

	0310
	0311
	1306

	5510
	5610
	2022

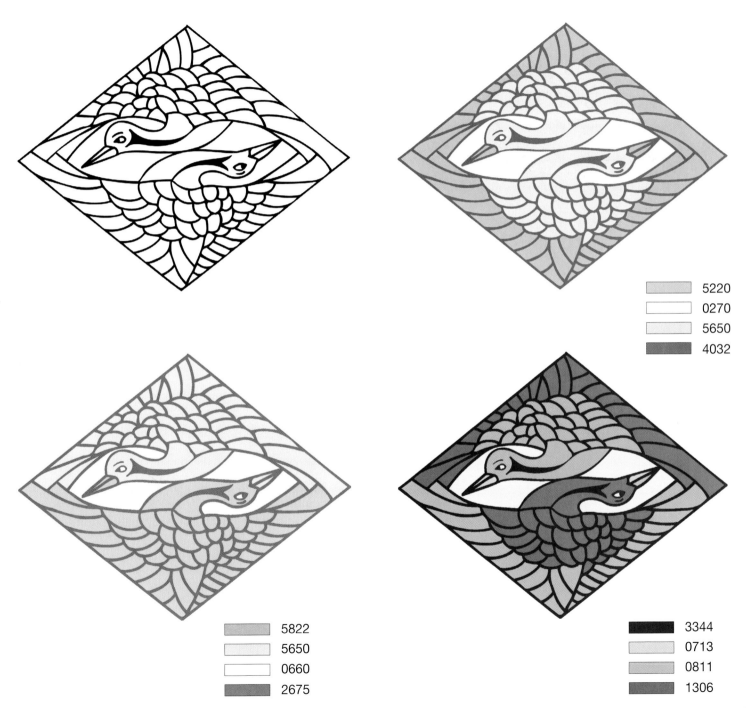

5220
0270
5650
4032

5822
5650
0660
2675

3344
0713
0811
1306

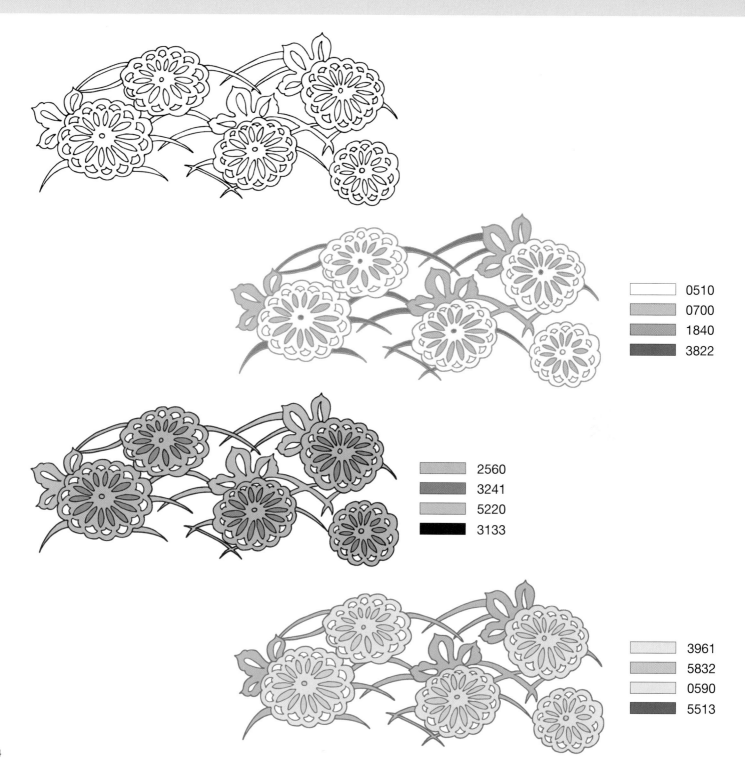

	0510
	0700
	1840
	3822

	2560
	3241
	5220
	3133

	3961
	5832
	0590
	5513

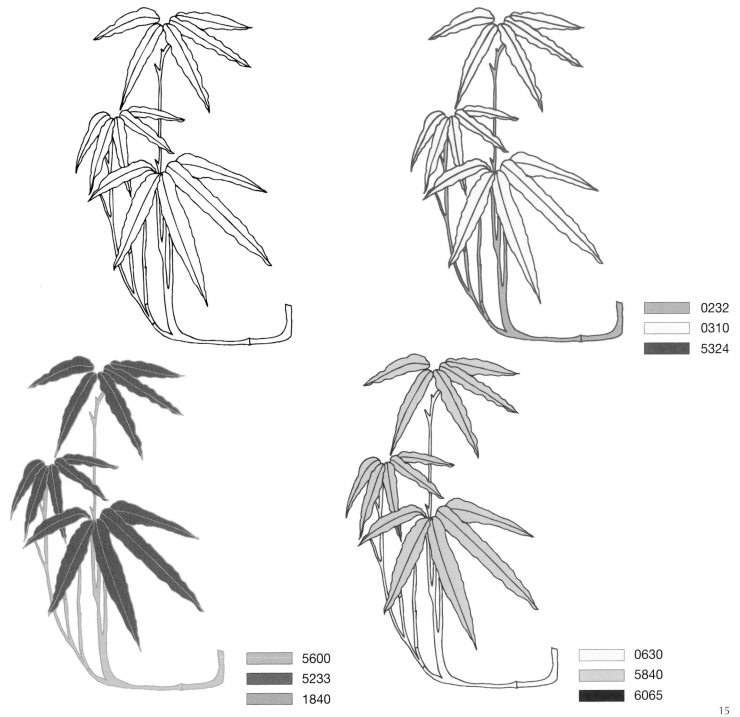

0232
0310
5324

5600
5233
1840

0630
5840
6065

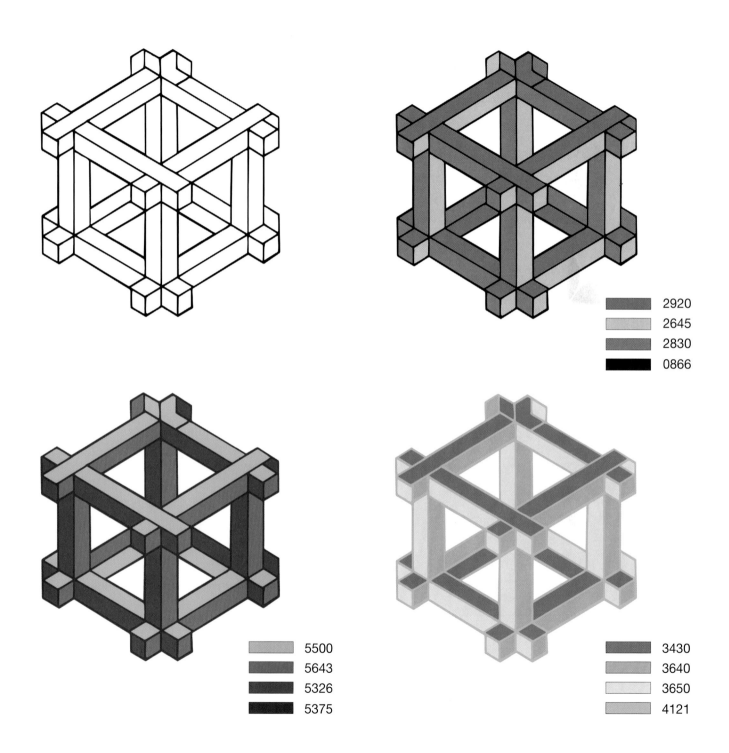

2920
2645
2830
0866

5500
5643
5326
5375

3430
3640
3650
4121

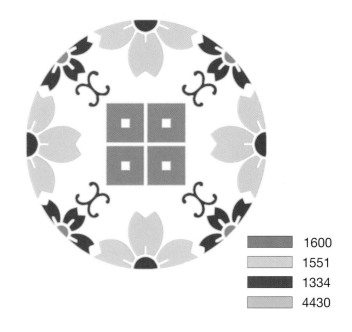

1600
1551
1334
4430

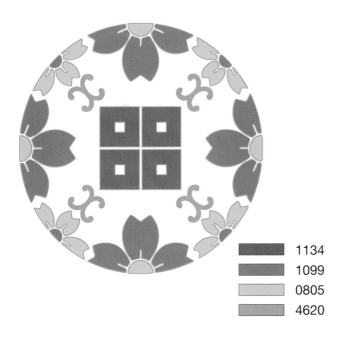

1134
1099
0805
4620

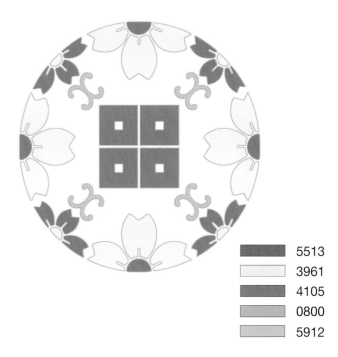

5513
3961
4105
0800
5912

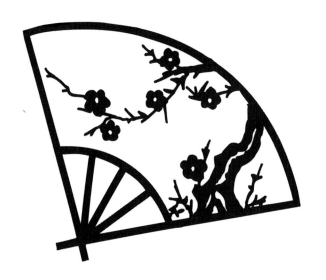

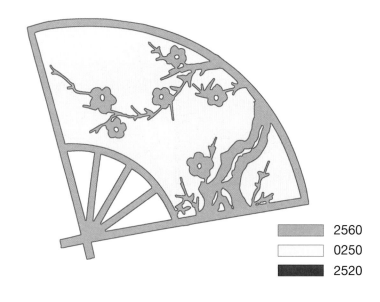

	2560
	0250
	2520

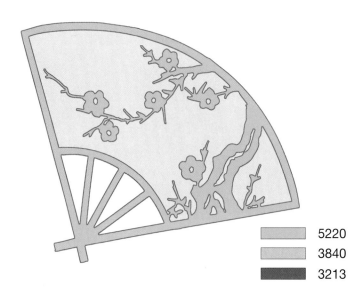

	5220
	3840
	3213

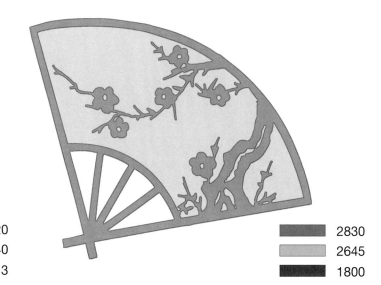

	2830
	2645
	1800

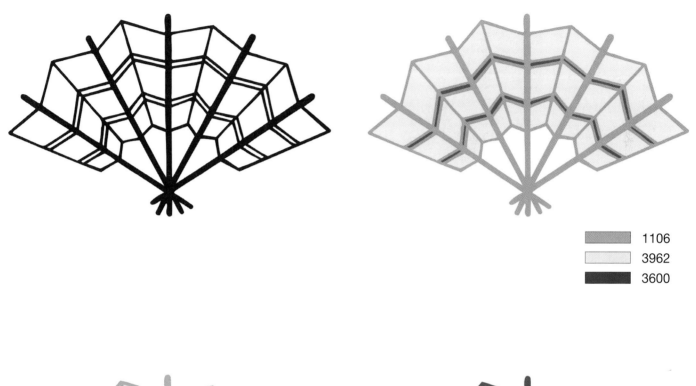

1106
3962
3600

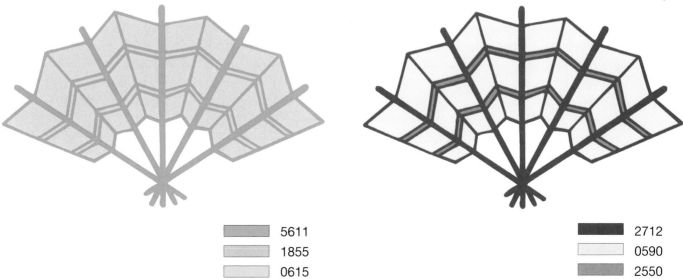

5611
1855
0615

2712
0590
2550

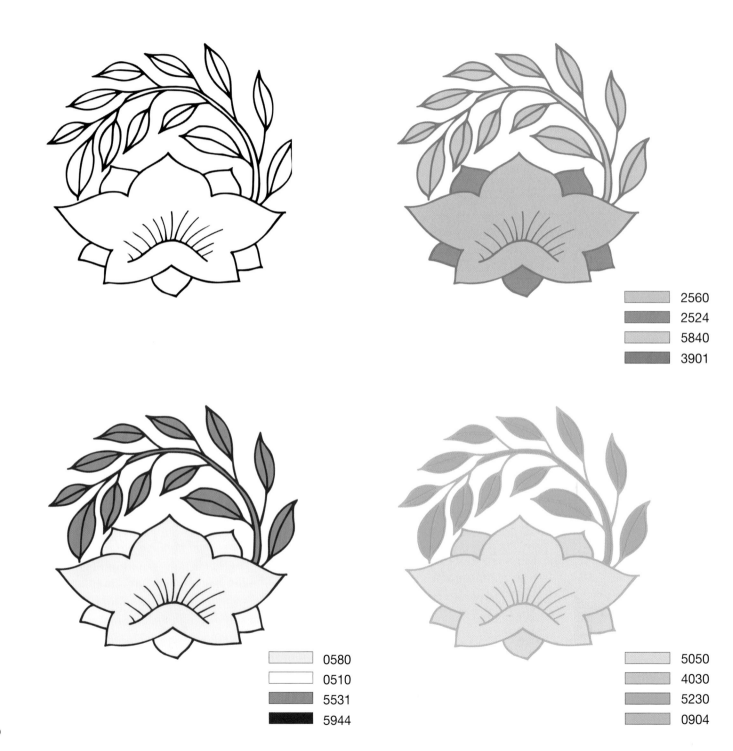

2560
2524
5840
3901

0580
0510
5531
5944

5050
4030
5230
0904

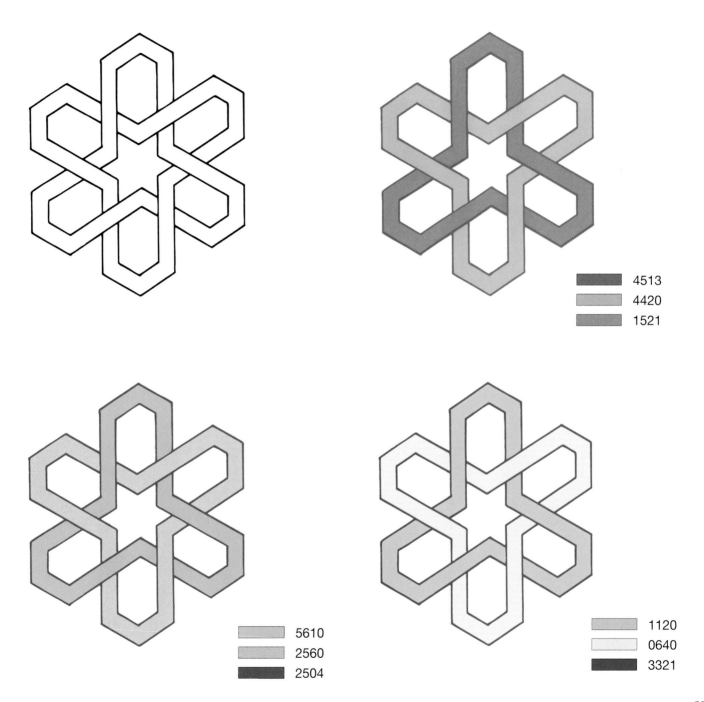

4513
4420
1521

5610
2560
2504

1120
0640
3321

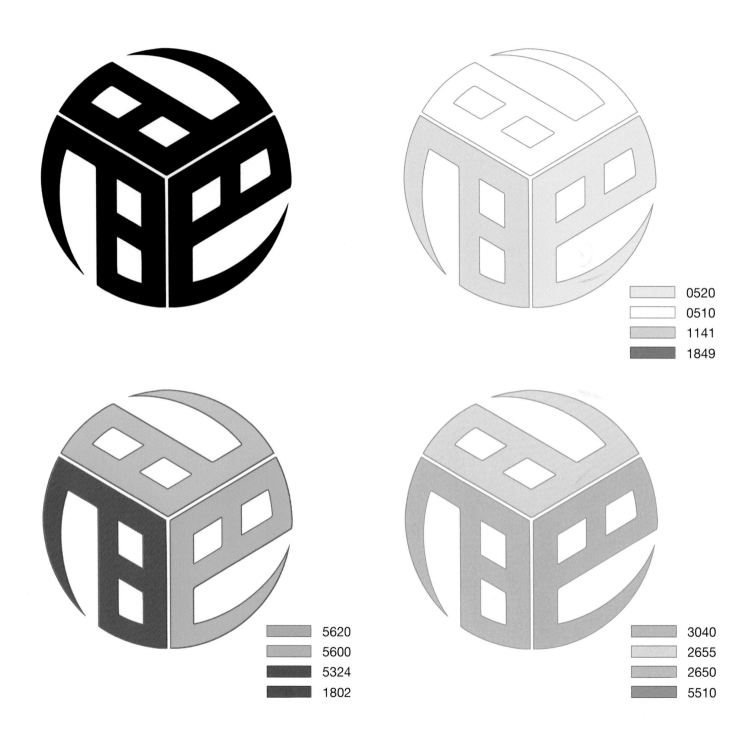

0520
0510
1141
1849

5620
5600
5324
1802

3040
2655
2650
5510

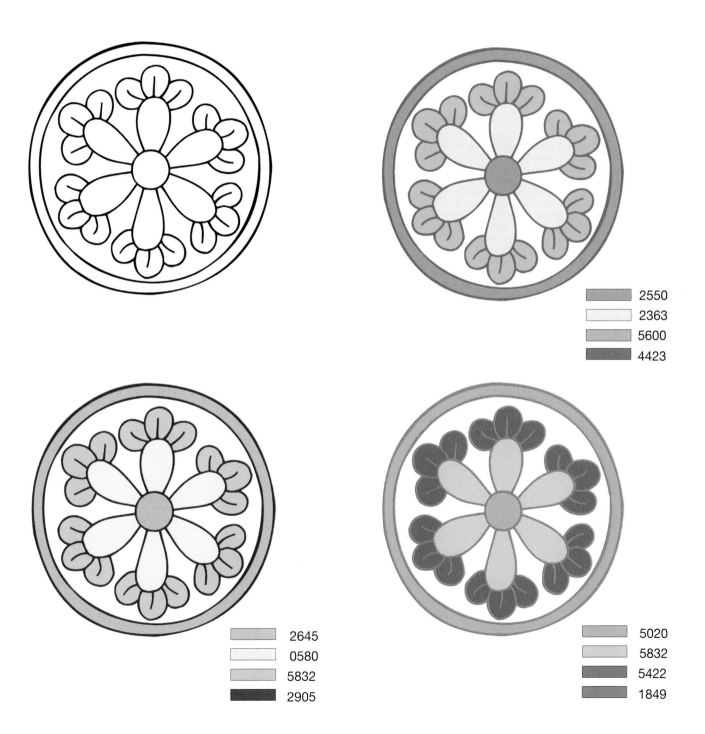

2550
2363
5600
4423

2645
0580
5832
2905

5020
5832
5422
1849

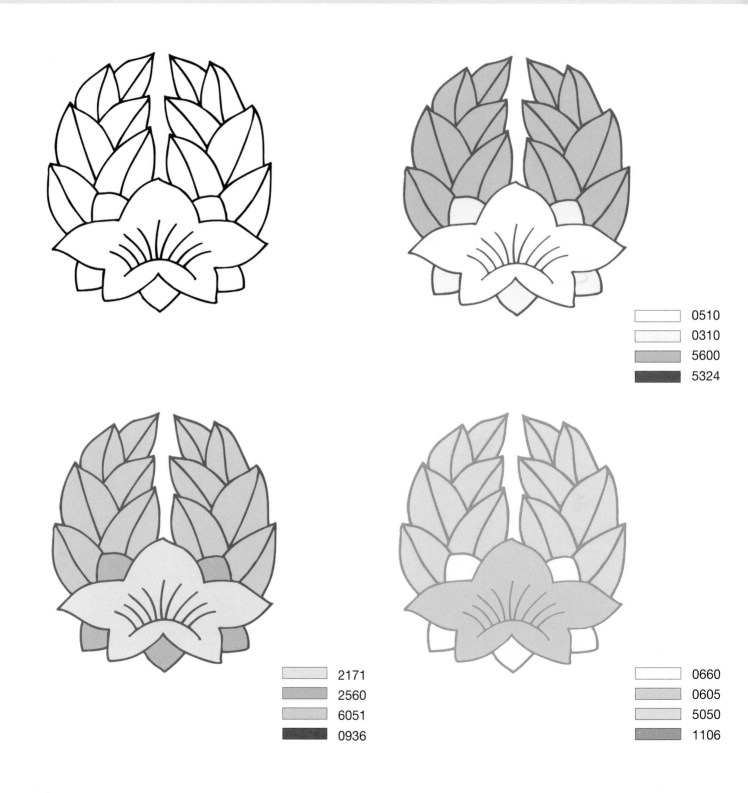

0510
0310
5600
5324

2171
2560
6051
0936

0660
0605
5050
1106

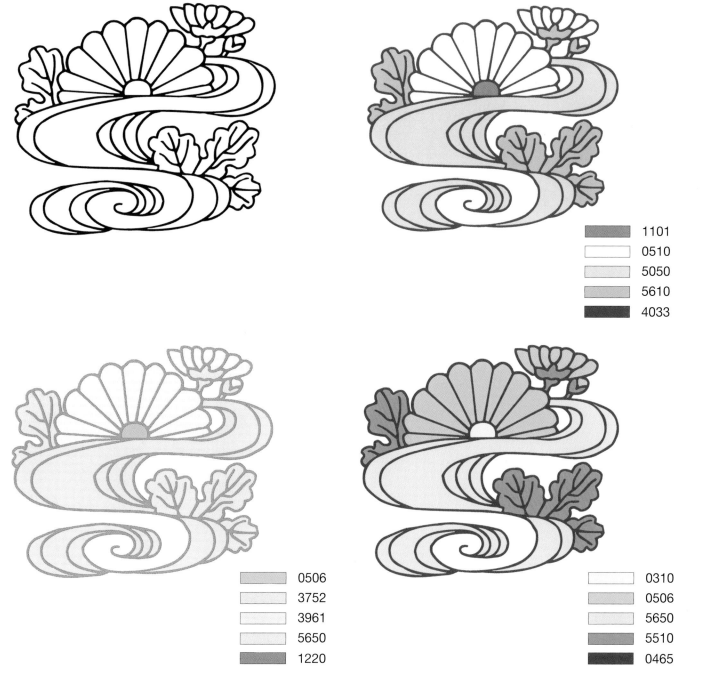

	1101
	0510
	5050
	5610
	4033

	0506
	3752
	3961
	5650
	1220

	0310
	0506
	5650
	5510
	0465

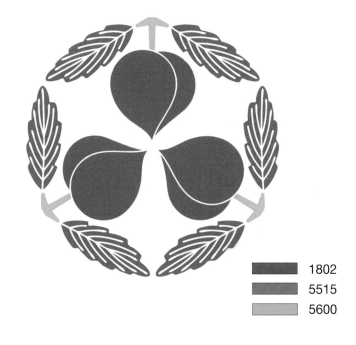

	1802
	5515
	5600

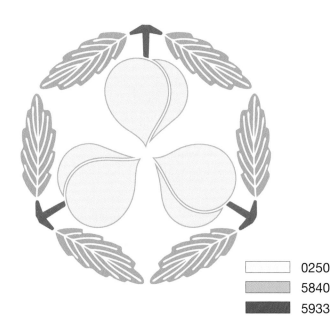

	0250
	5840
	5933

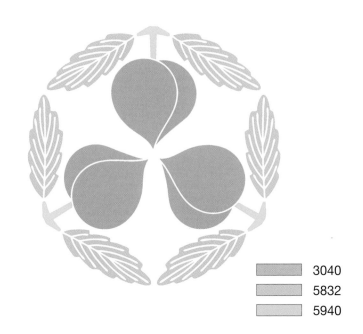

	3040
	5832
	5940

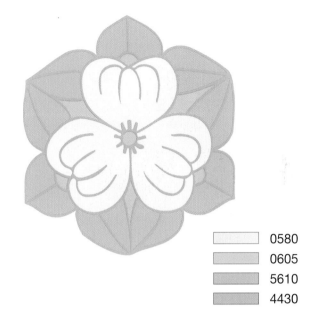

	0580
	0605
	5610
	4430

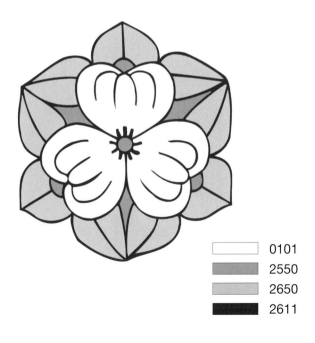

	0101
	2550
	2650
	2611

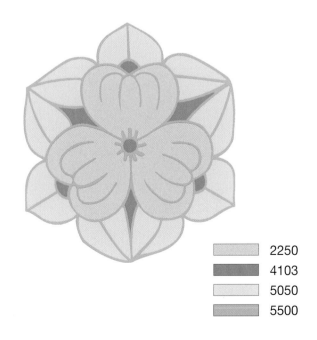

	2250
	4103
	5050
	5500

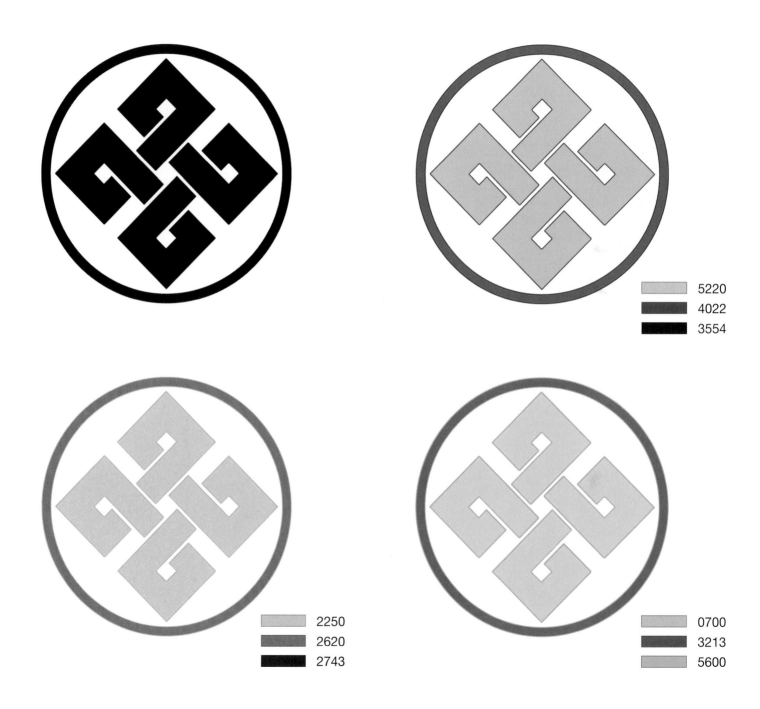

5220
4022
3554

2250
2620
2743

0700
3213
5600

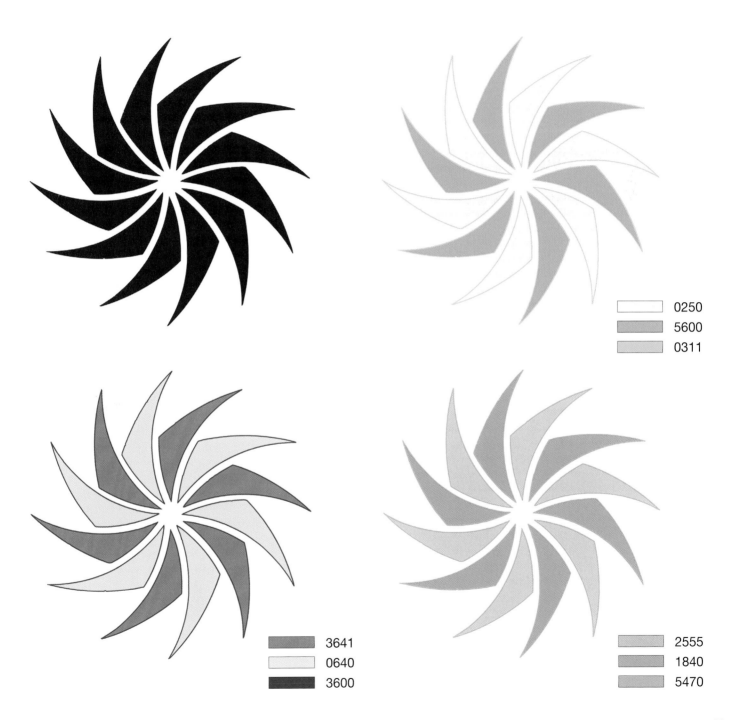

0250
5600
0311

3641
0640
3600

2555
1840
5470

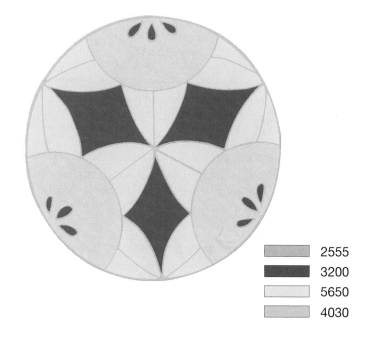

	2555
	3200
	5650
	4030

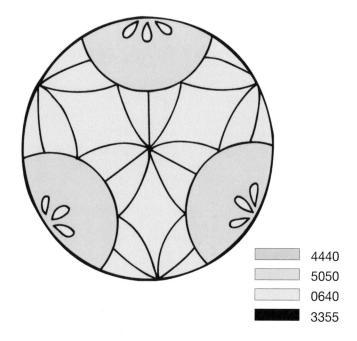

	4440
	5050
	0640
	3355

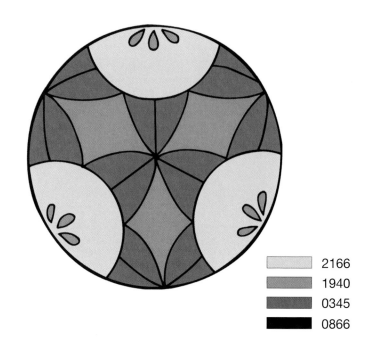

	2166
	1940
	0345
	0866

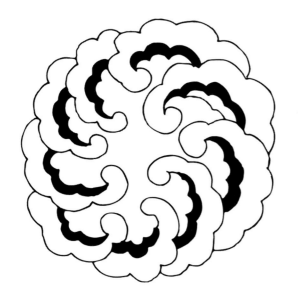

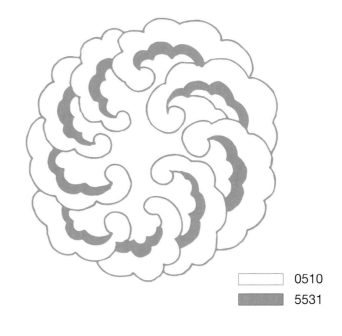

0510
5531

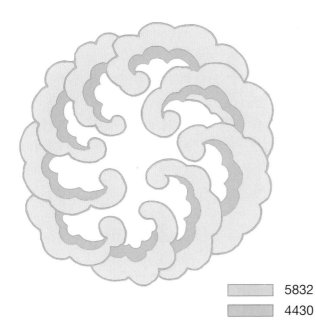

5832
4430

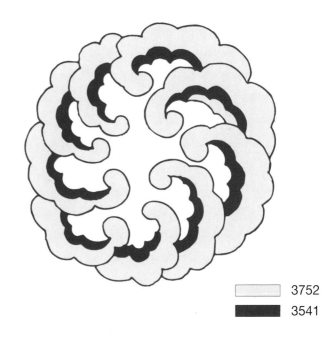

3752
3541

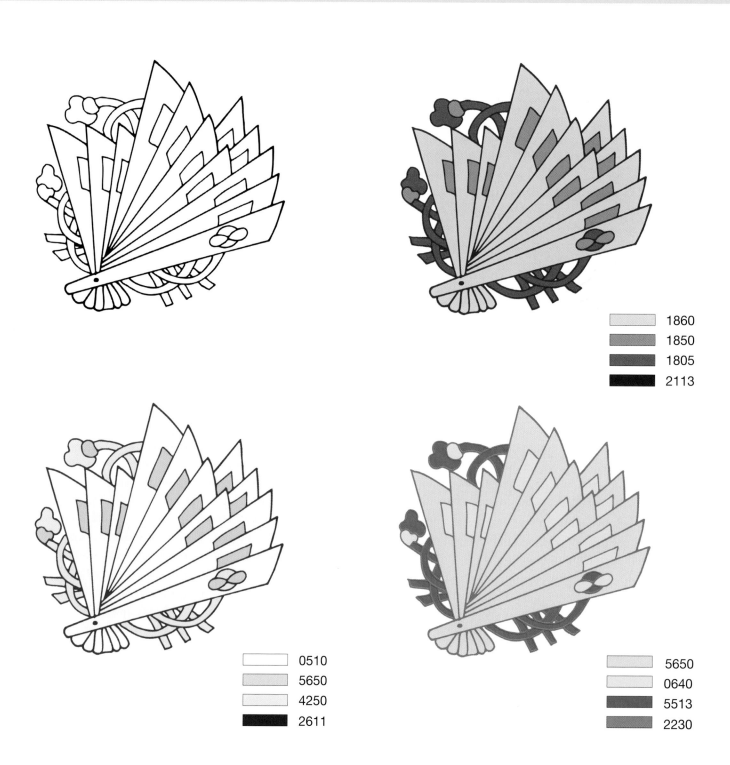

1860
1850
1805
2113

0510
5650
4250
2611

5650
0640
5513
2230

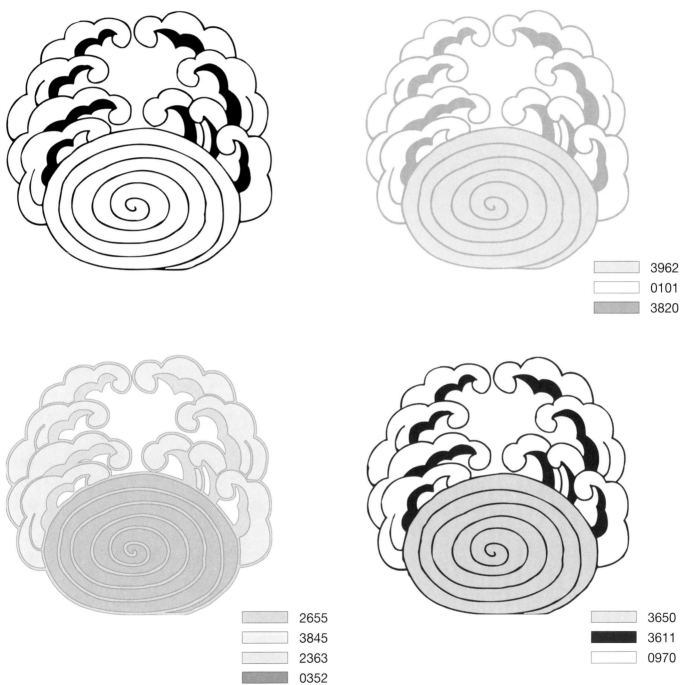

3962
0101
3820

2655
3845
2363
0352

3650
3611
0970

33

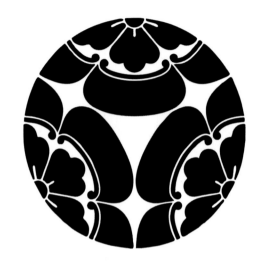

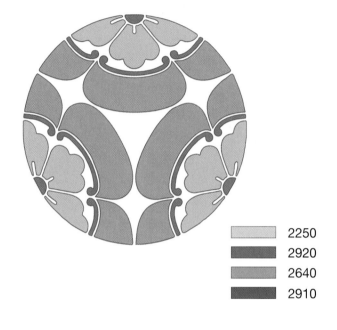

2250
2920
2640
2910

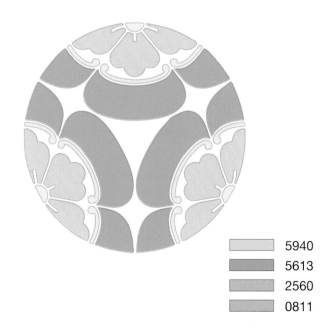

5940
5613
2560
0811

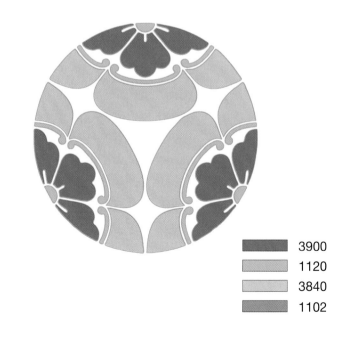

3900
1120
3840
1102

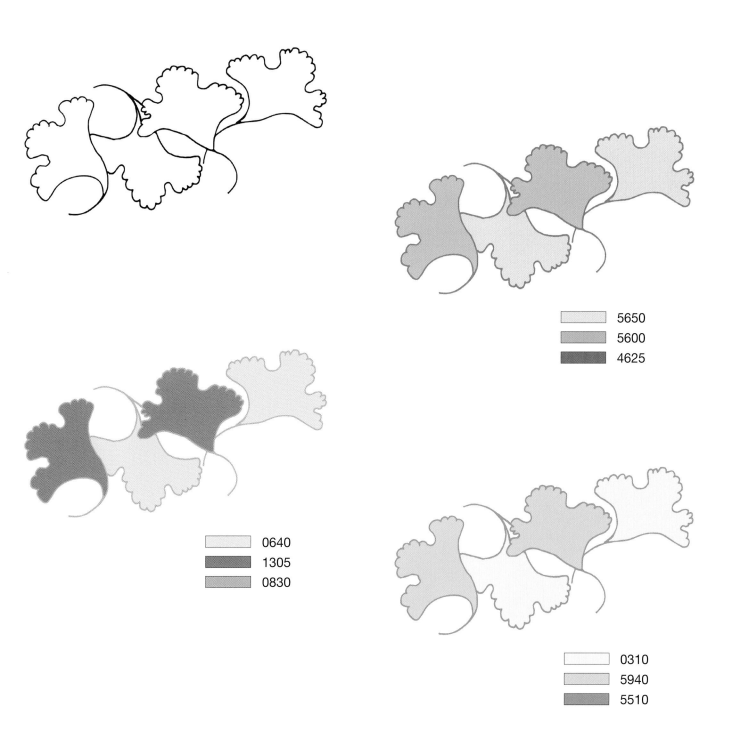

5650
5600
4625

0640
1305
0830

0310
5940
5510

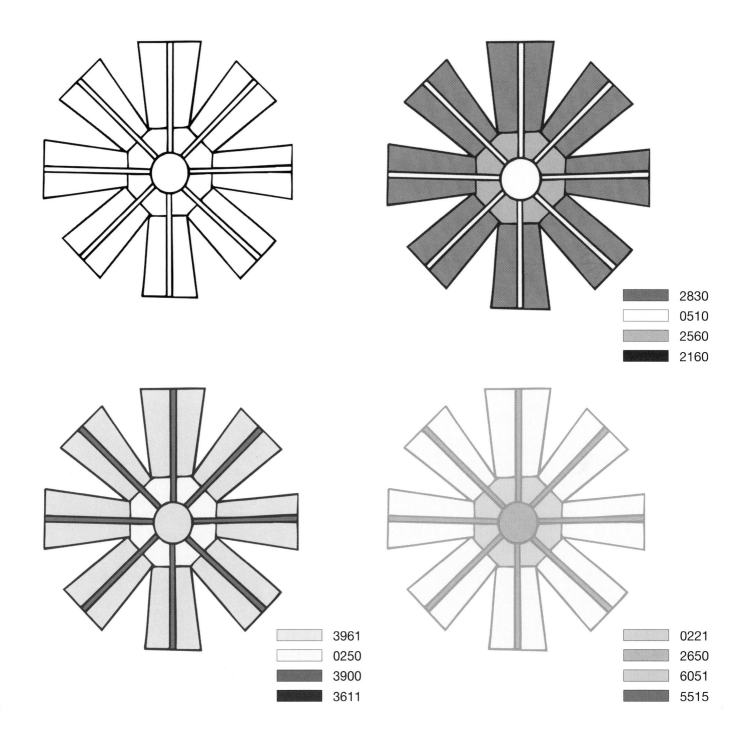

2830
0510
2560
2160

3961
0250
3900
3611

0221
2650
6051
5515

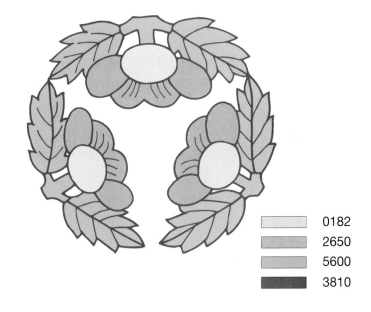

	0182
	2650
	5600
	3810

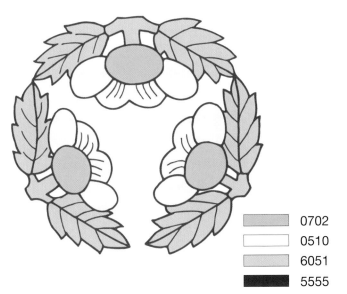

	0702
	0510
	6051
	5555

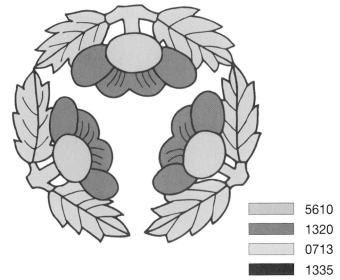

	5610
	1320
	0713
	1335

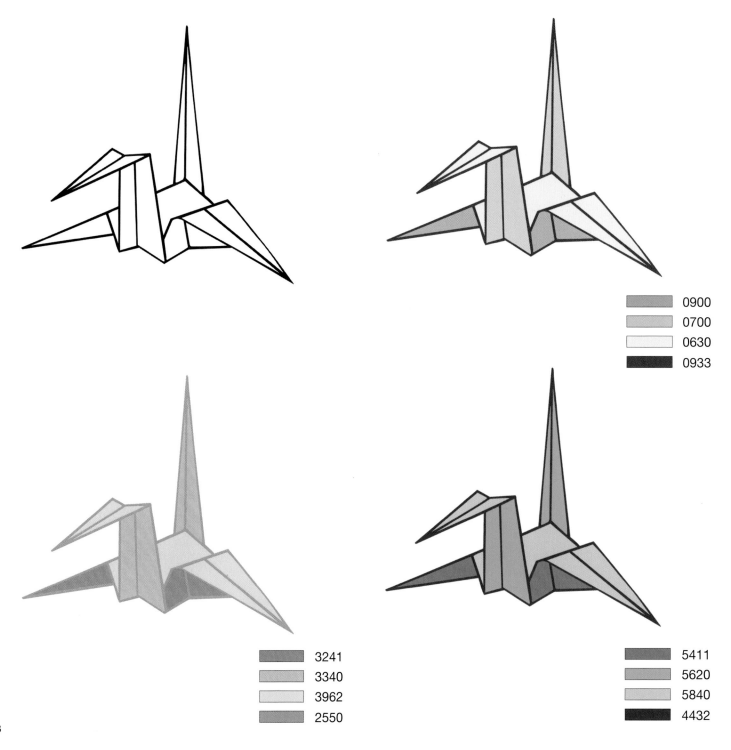

0900
0700
0630
0933

3241
3340
3962
2550

5411
5620
5840
4432

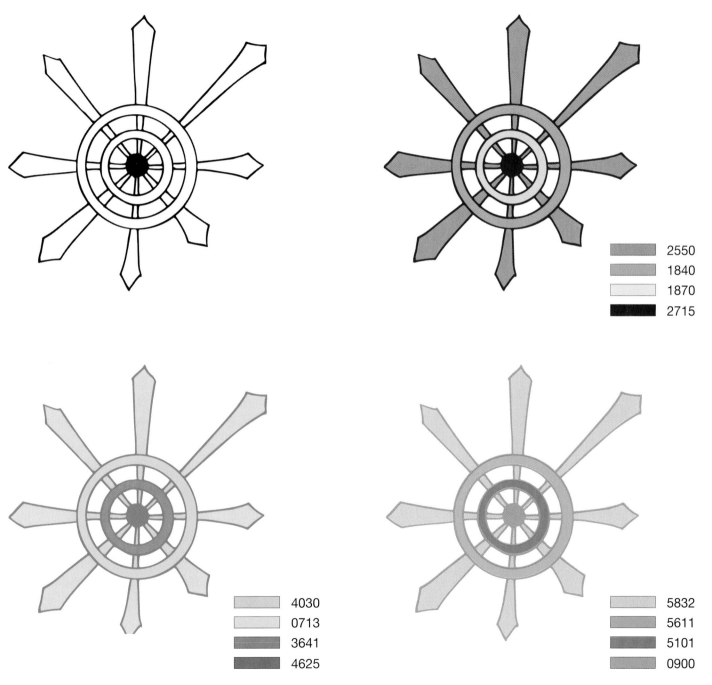

2550
1840
1870
2715

4030
0713
3641
4625

5832
5611
5101
0900

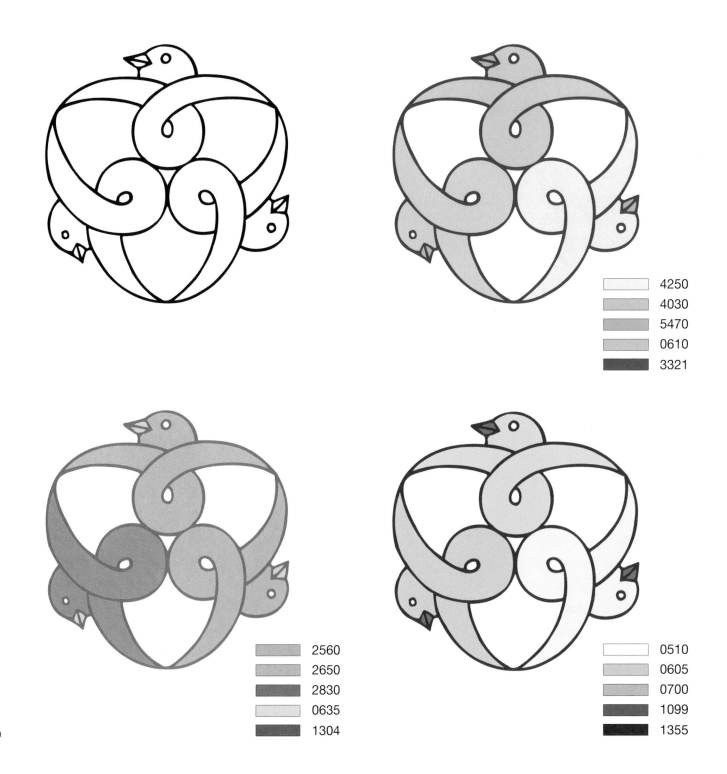

4250
4030
5470
0610
3321

2560
2650
2830
0635
1304

0510
0605
0700
1099
1355

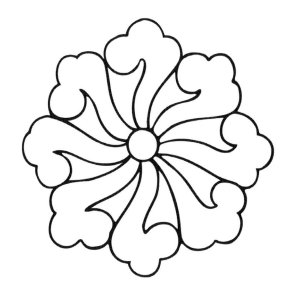

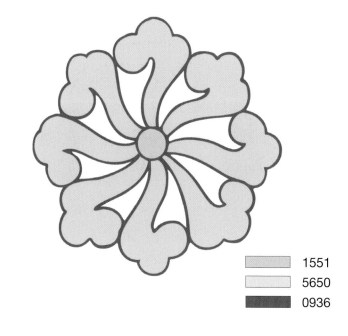

	1551
	5650
	0936

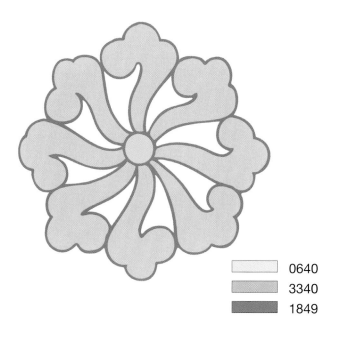

	0640
	3340
	1849

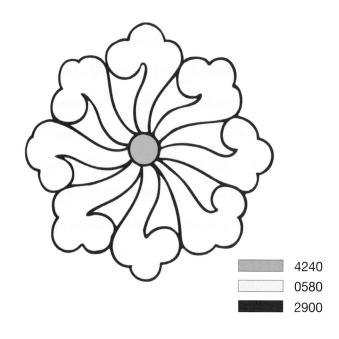

	4240
	0580
	2900

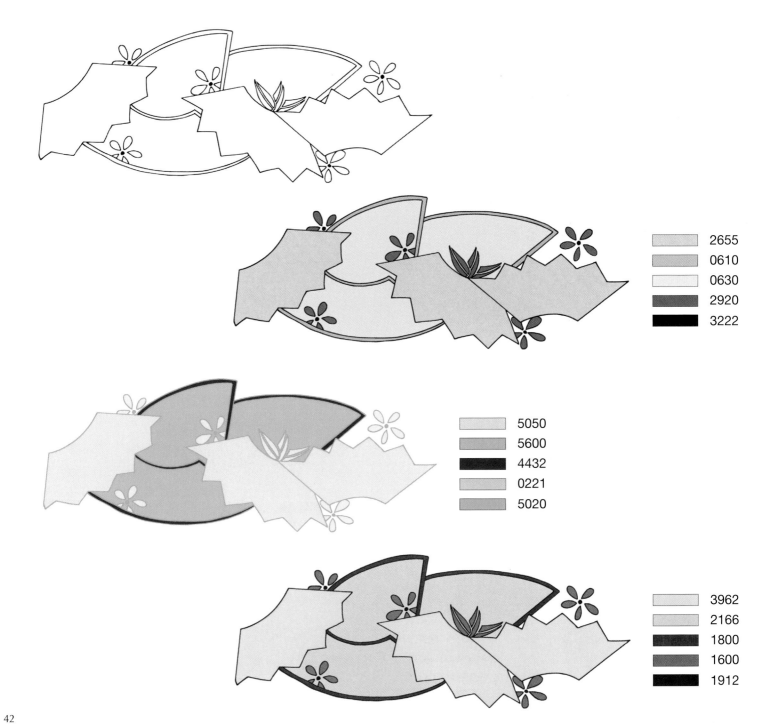

2655
0610
0630
2920
3222

5050
5600
4432
0221
5020

3962
2166
1800
1600
1912

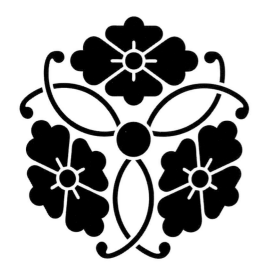

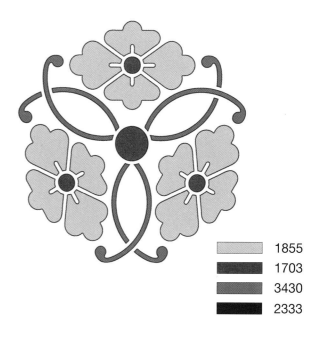

	1855
	1703
	3430
	2333

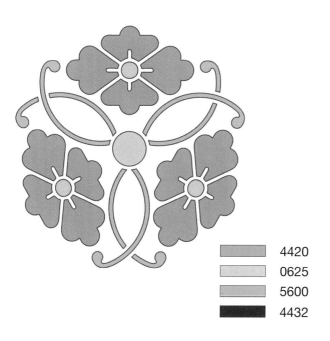

	4420
	0625
	5600
	4432

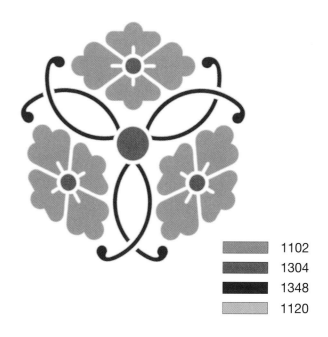

	1102
	1304
	1348
	1120

43

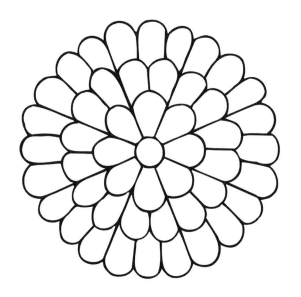

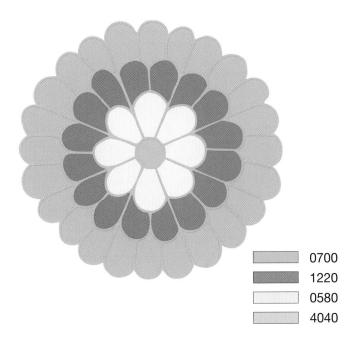

	0700
	1220
	0580
	4040

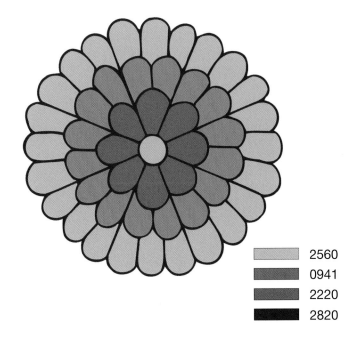

	2560
	0941
	2220
	2820

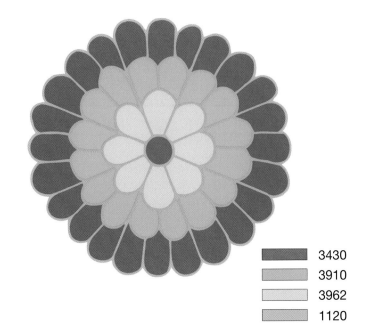

	3430
	3910
	3962
	1120

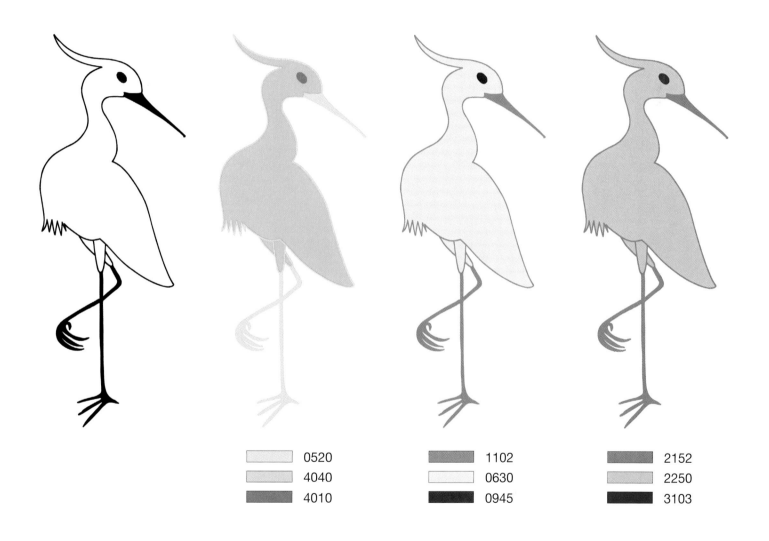

0520	
4040	
4010	

1102	
0630	
0945	

2152	
2250	
3103	

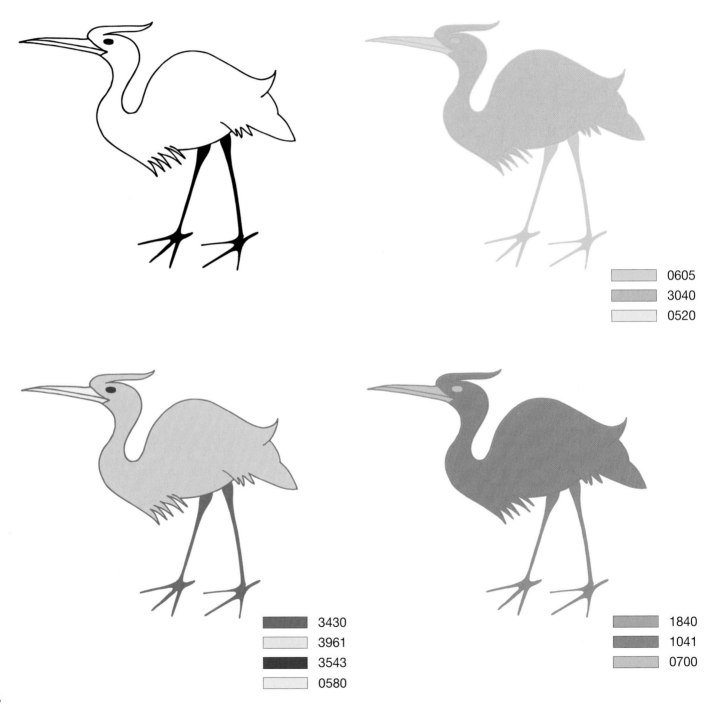

0605
3040
0520

3430
3961
3543
0580

1840
1041
0700

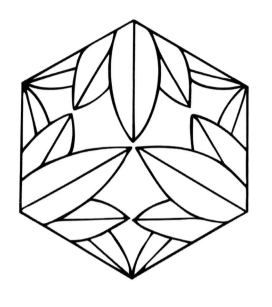

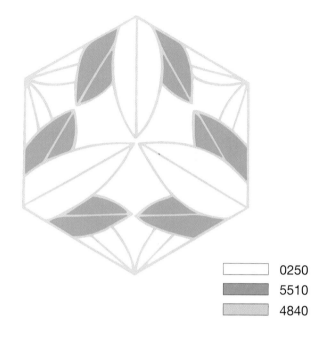

⬜	0250
⬛	5510
⬛	4840

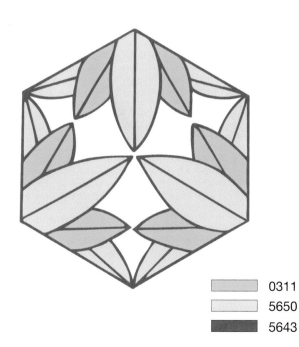

⬛	0311
⬜	5650
⬛	5643

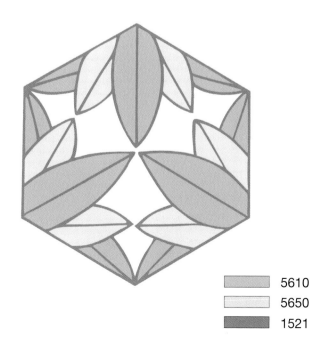

⬛	5610
⬜	5650
⬛	1521

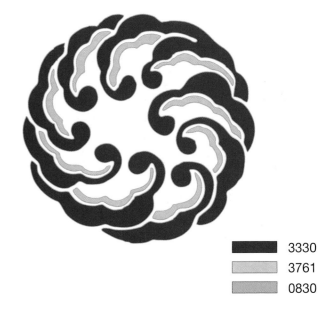

■	3330
■	3761
■	0830

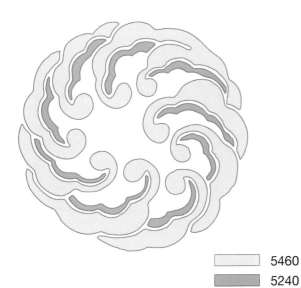

■	5460
■	5240
■	3901

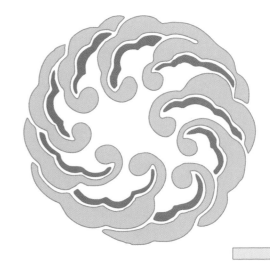

■	5650
■	3251
■	2620

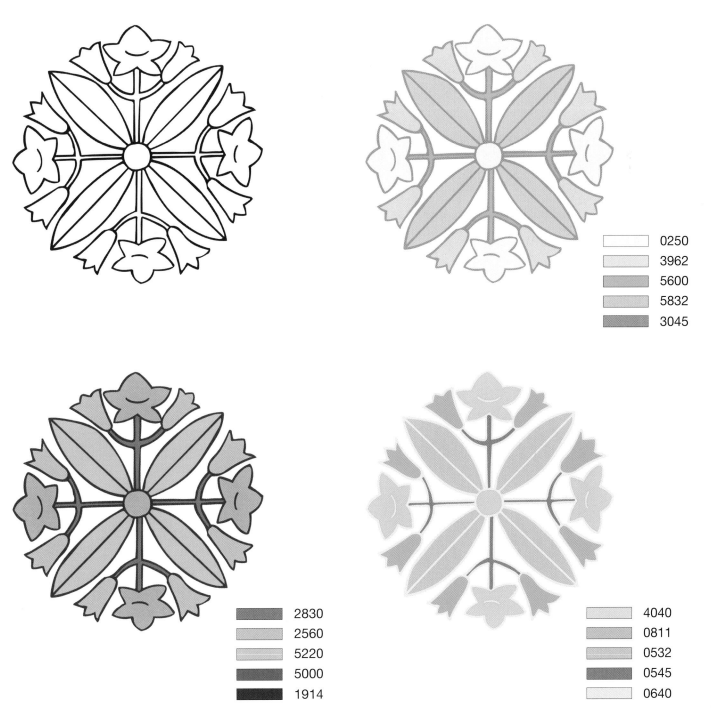

	0250
	3962
	5600
	5832
	3045

	2830
	2560
	5220
	5000
	1914

	4040
	0811
	0532
	0545
	0640

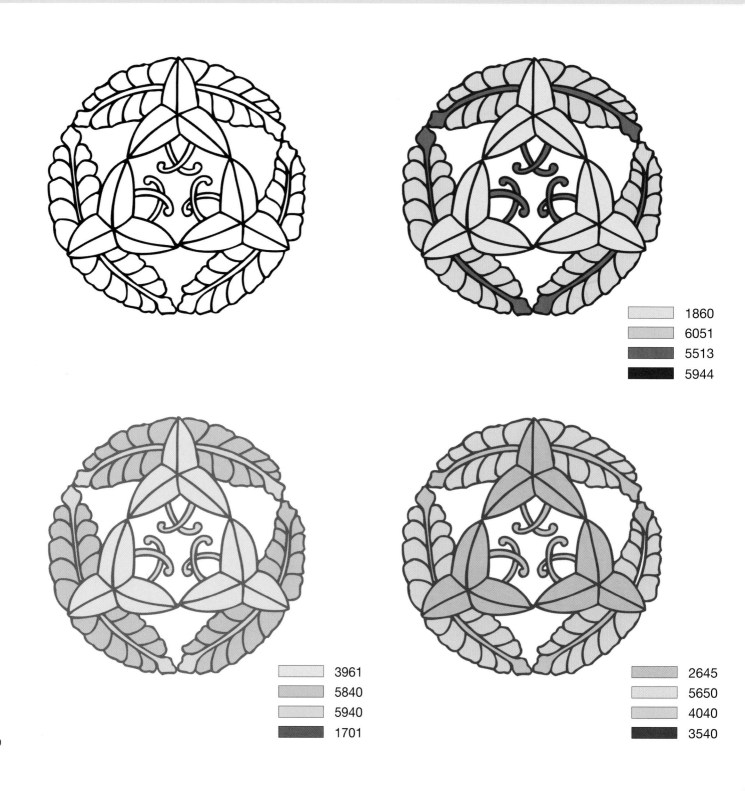

1860
6051
5513
5944

3961
5840
5940
1701

2645
5650
4040
3540

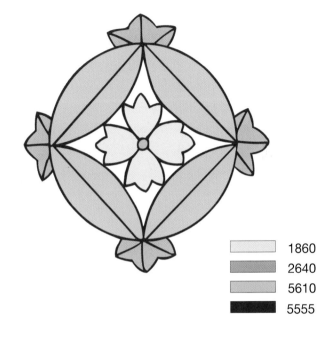

	1860
	2640
	5610
	5555

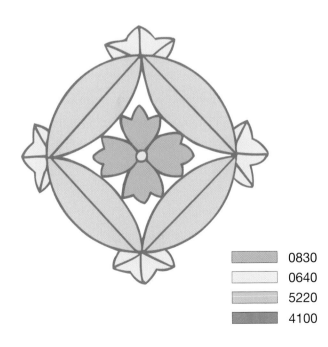

	0830
	0640
	5220
	4100

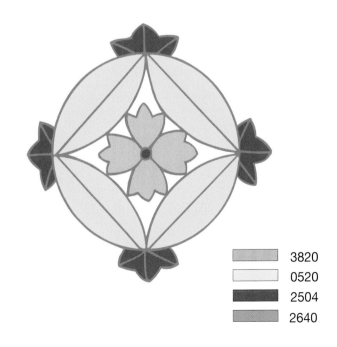

	3820
	0520
	2504
	2640

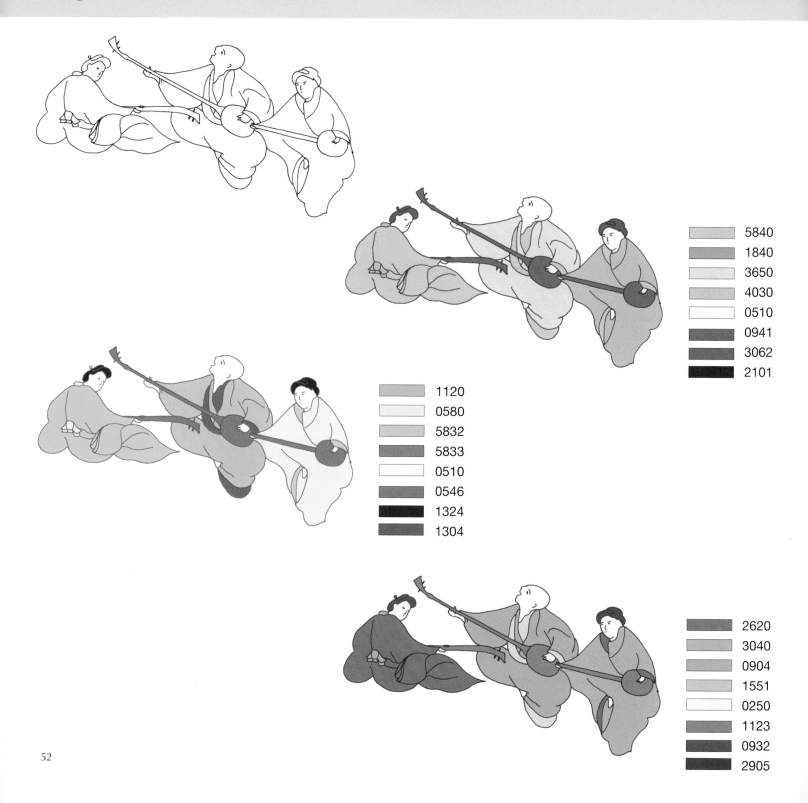

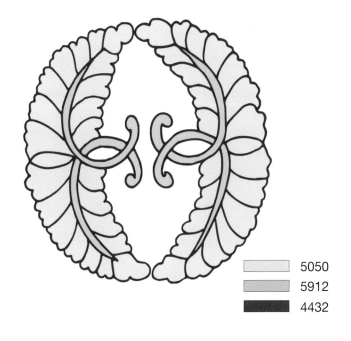

	5050
	5912
	4432

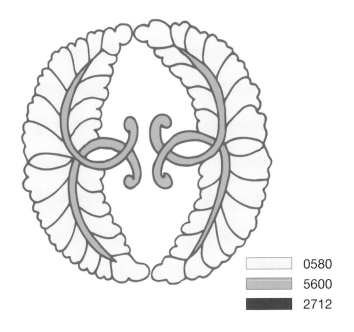

	0580
	5600
	2712

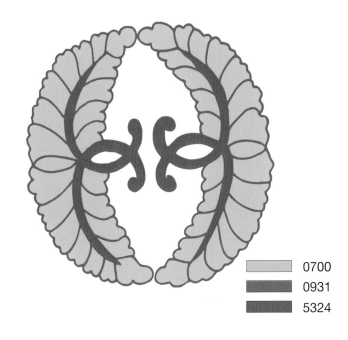

	0700
	0931
	5324

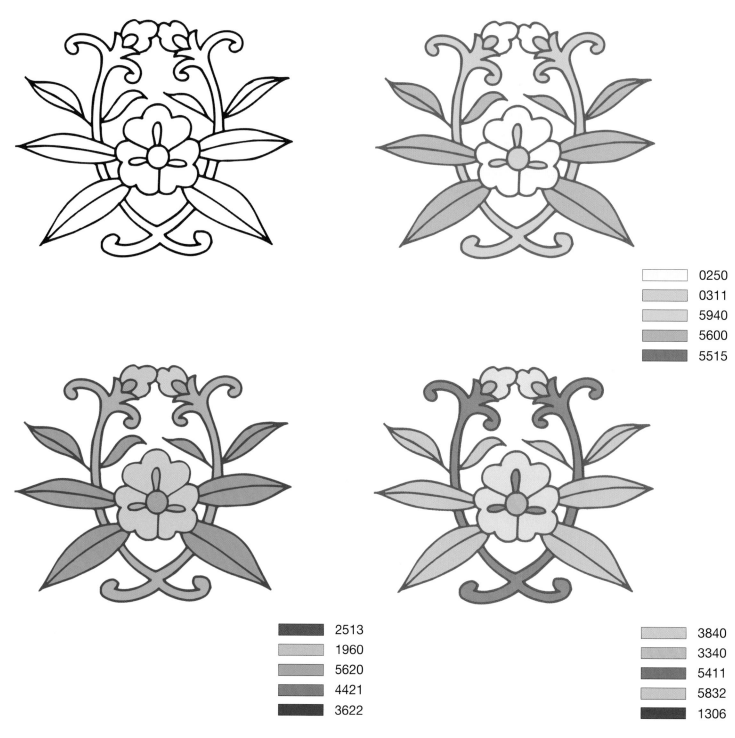

	0250
	0311
	5940
	5600
	5515

	2513
	1960
	5620
	4421
	3622

	3840
	3340
	5411
	5832
	1306

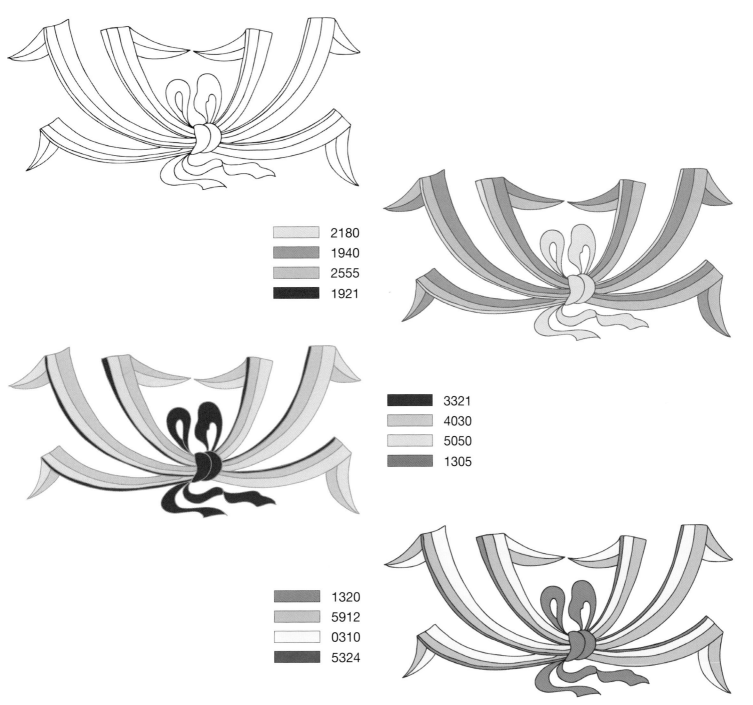

2180
1940
2555
1921

3321
4030
5050
1305

1320
5912
0310
5324

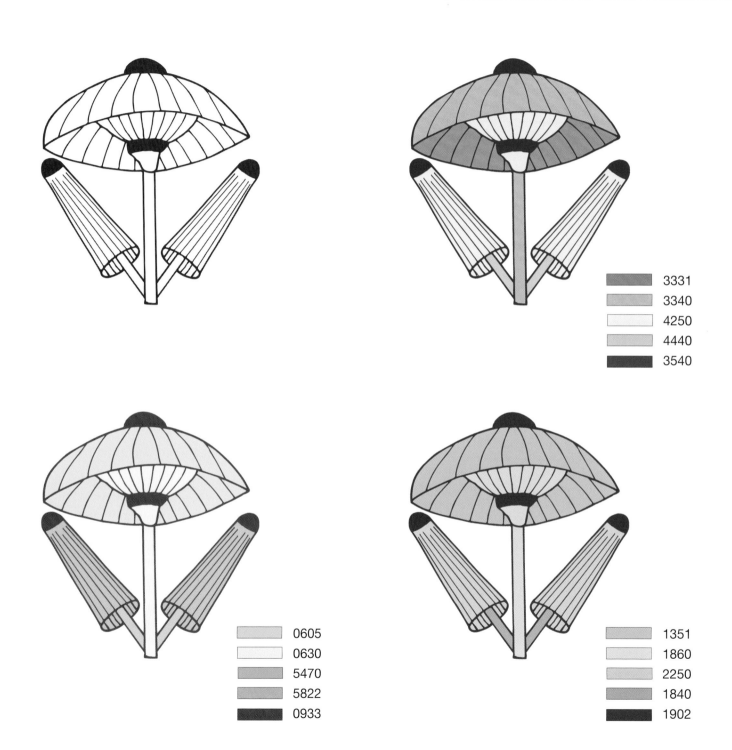

	3331
	3340
	4250
	4440
	3540

	0605
	0630
	5470
	5822
	0933

	1351
	1860
	2250
	1840
	1902

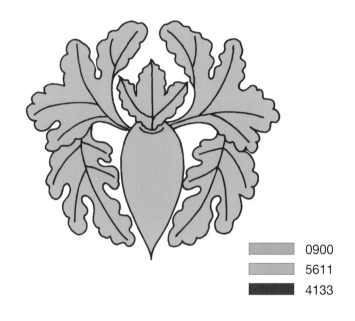

	0900
	5611
	4133

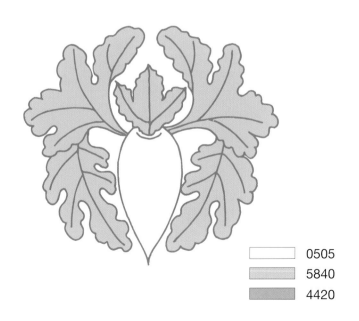

	0505
	5840
	4420

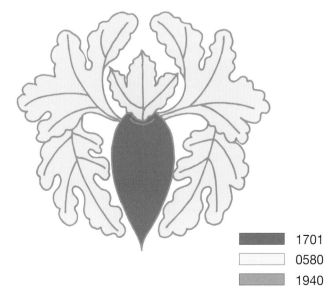

	1701
	0580
	1940

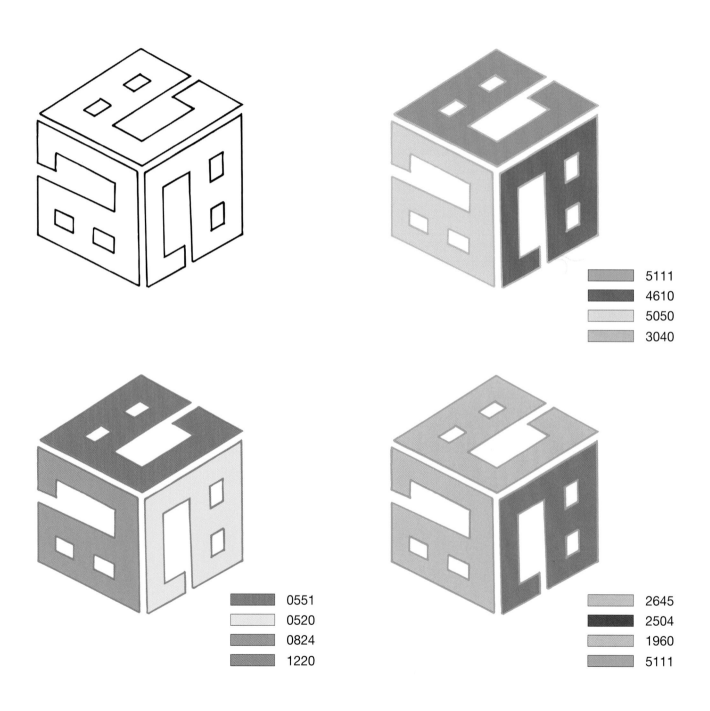

5111
4610
5050
3040

0551
0520
0824
1220

2645
2504
1960
5111

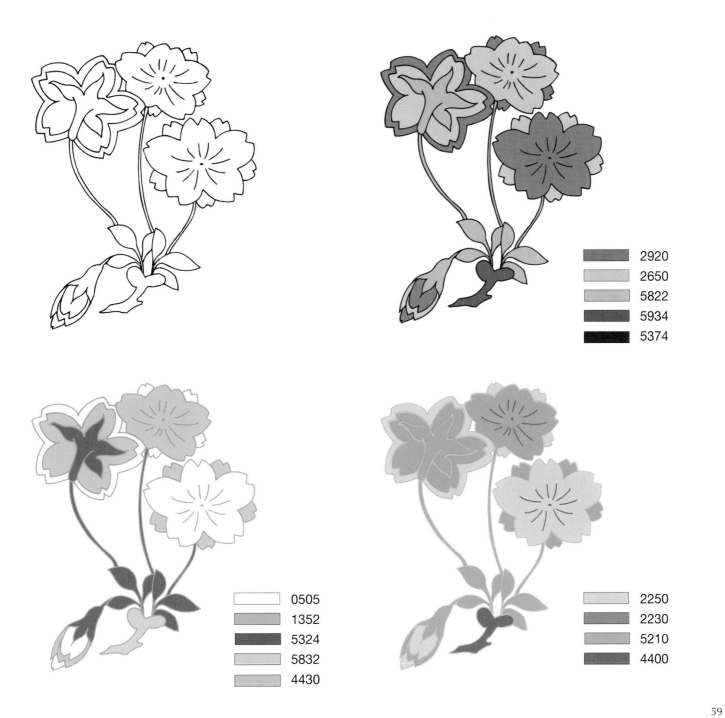

2920
2650
5822
5934
5374

0505
1352
5324
5832
4430

2250
2230
5210
4400

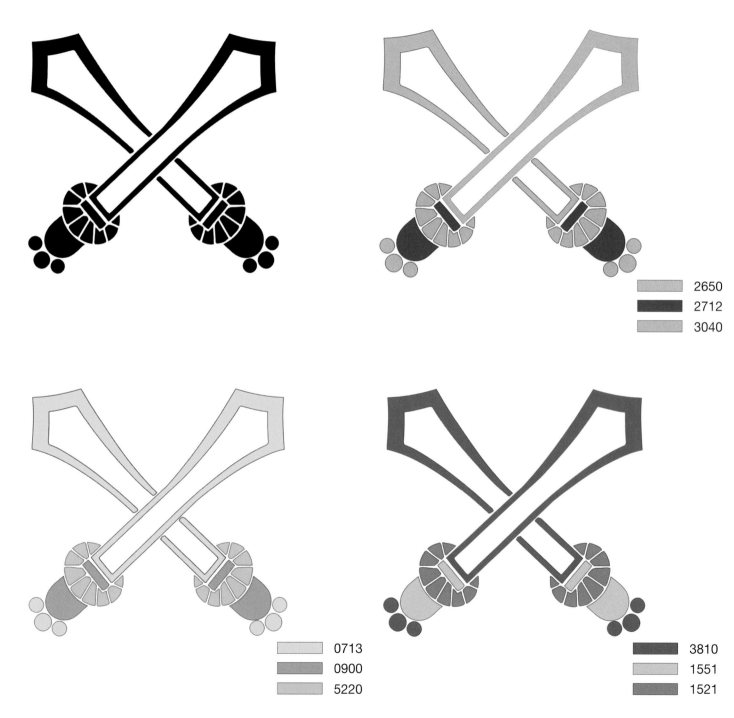

2650
2712
3040

0713
0900
5220

3810
1551
1521

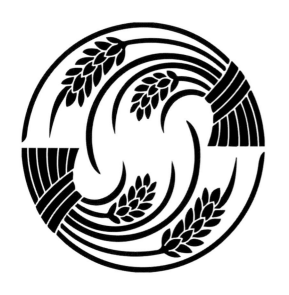

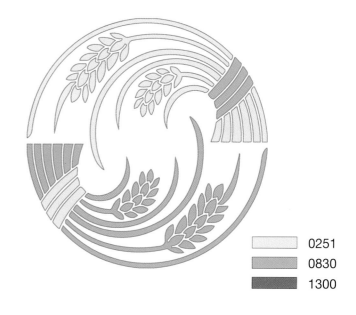

	0251
	0830
	1300

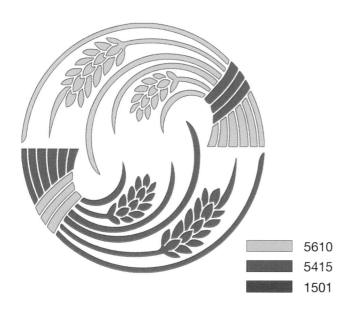

	5610
	5415
	1501

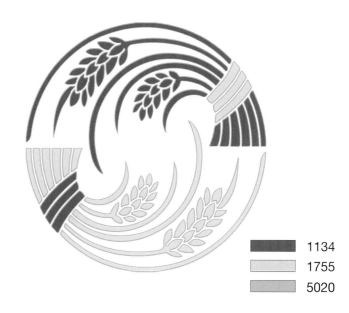

	1134
	1755
	5020

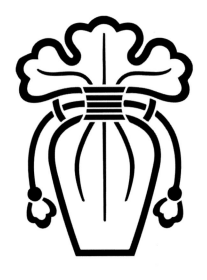

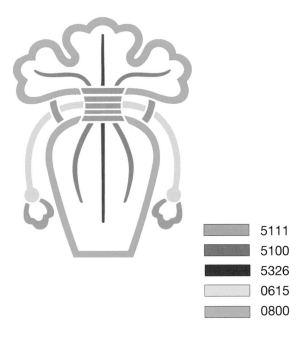

	5111
	5100
	5326
	0615
	0800

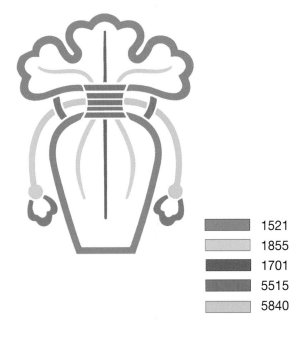

	1521
	1855
	1701
	5515
	5840

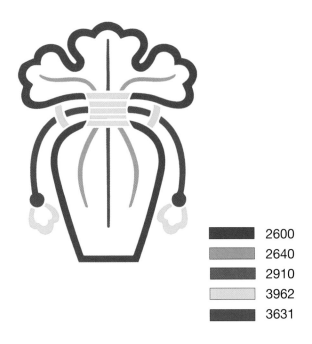

	2600
	2640
	2910
	3962
	3631

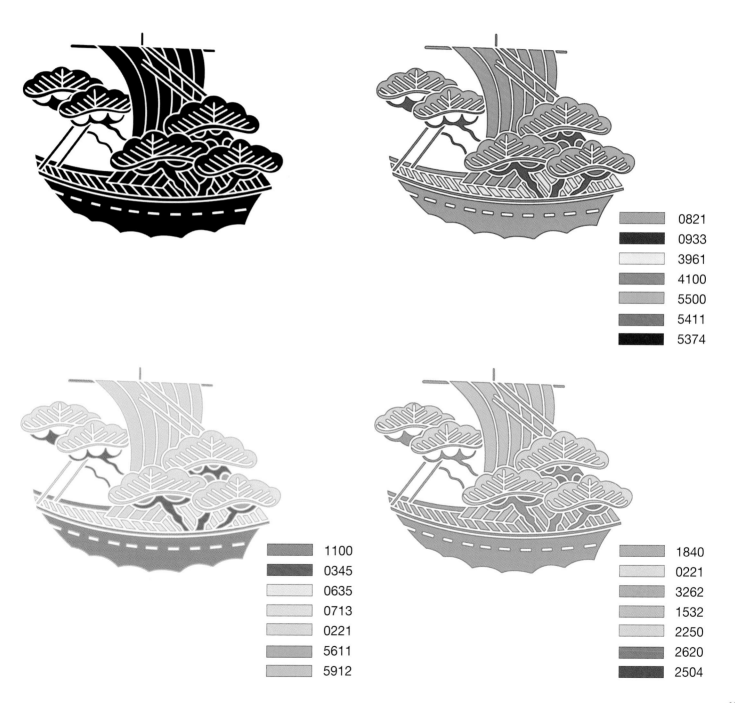

056

0821
0933
3961
4100
5500
5411
5374

1100
0345
0635
0713
0221
5611
5912

1840
0221
3262
1532
2250
2620
2504

63

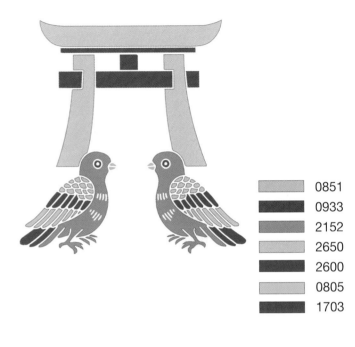

	0851
	0933
	2152
	2650
	2600
	0805
	1703

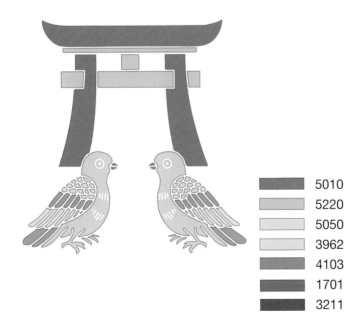

	5010
	5220
	5050
	3962
	4103
	1701
	3211

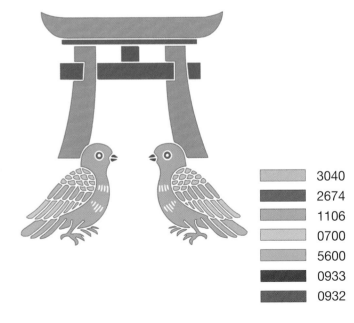

	3040
	2674
	1106
	0700
	5600
	0933
	0932

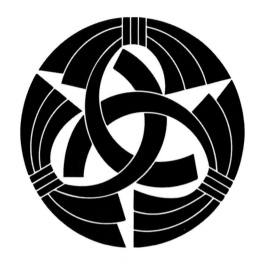

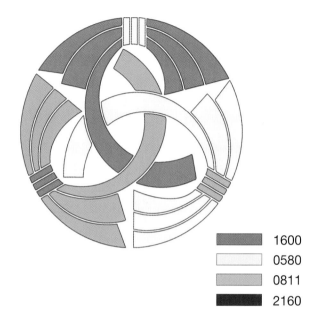

	1600
	0580
	0811
	2160

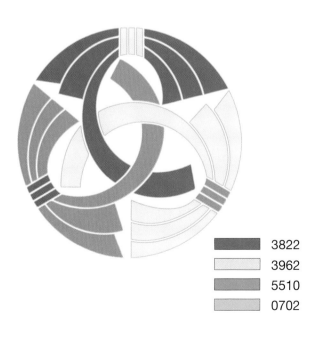

	3822
	3962
	5510
	0702

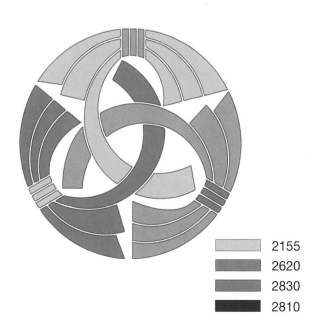

	2155
	2620
	2830
	2810

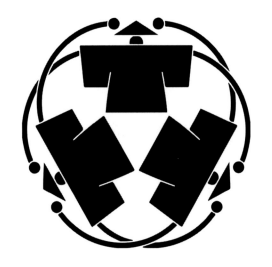

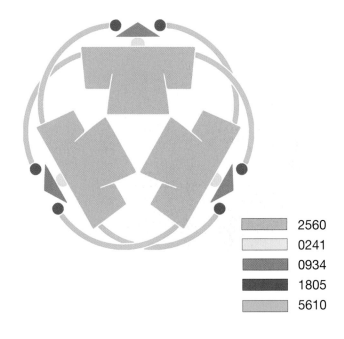

	2560
	0241
	0934
	1805
	5610

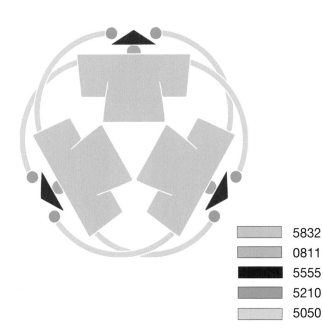

	5832
	0811
	5555
	5210
	5050

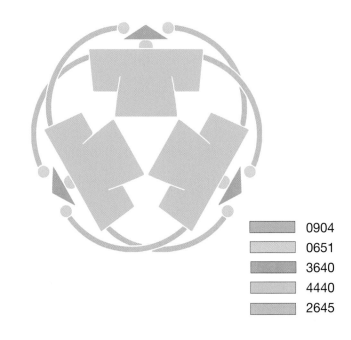

	0904
	0651
	3640
	4440
	2645

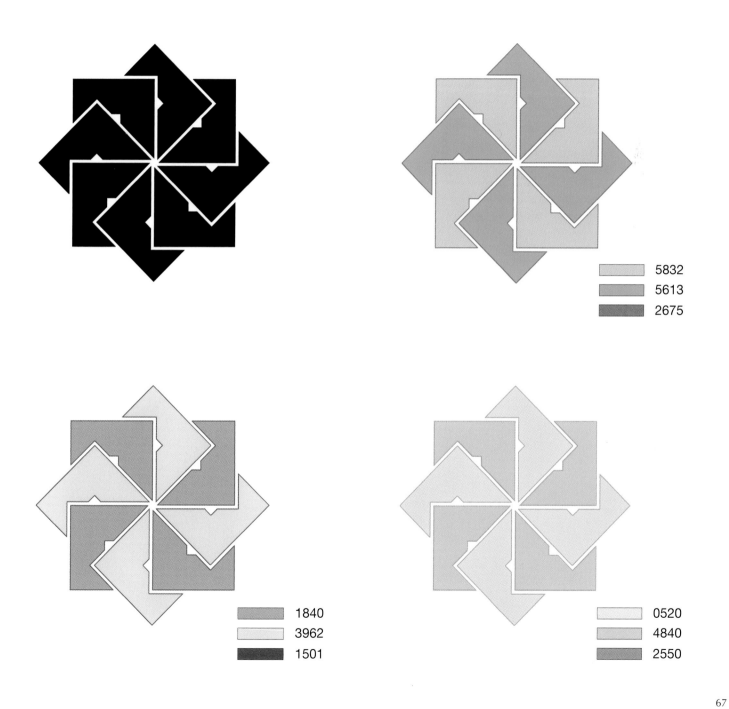

5832
5613
2675

1840
3962
1501

0520
4840
2550

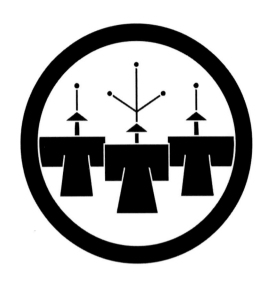

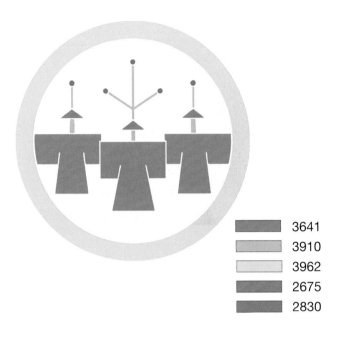

	3641
	3910
	3962
	2675
	2830

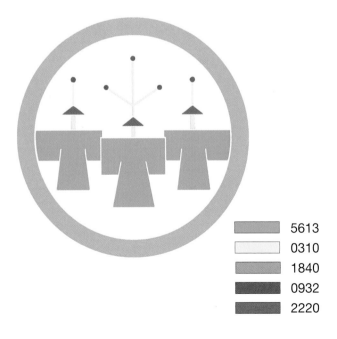

	5613
	0310
	1840
	0932
	2220

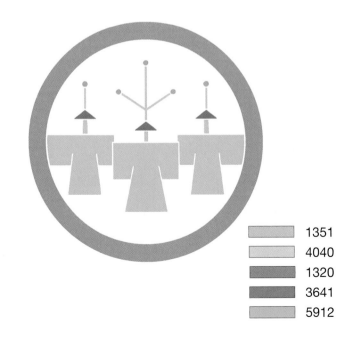

	1351
	4040
	1320
	3641
	5912

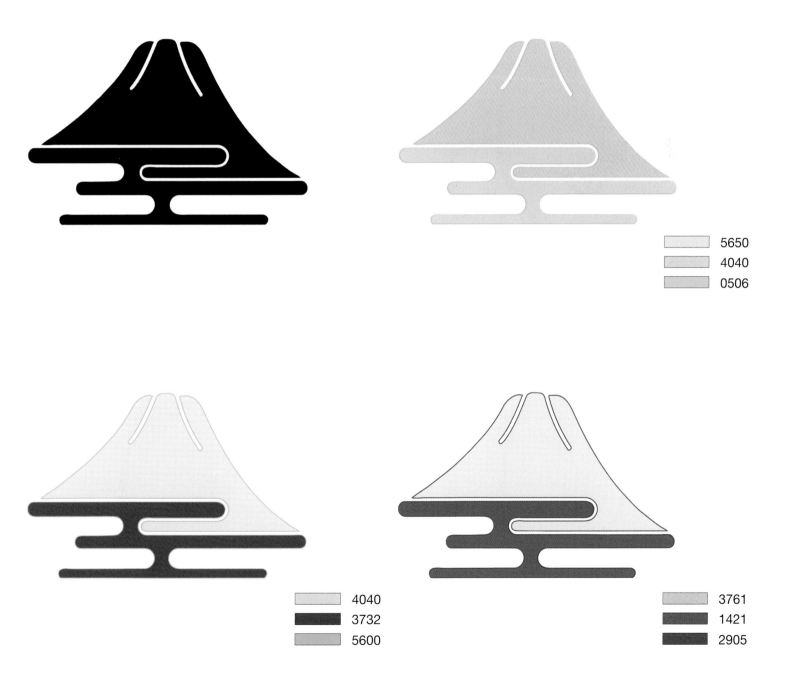

5650
4040
0506

4040
3732
5600

3761
1421
2905

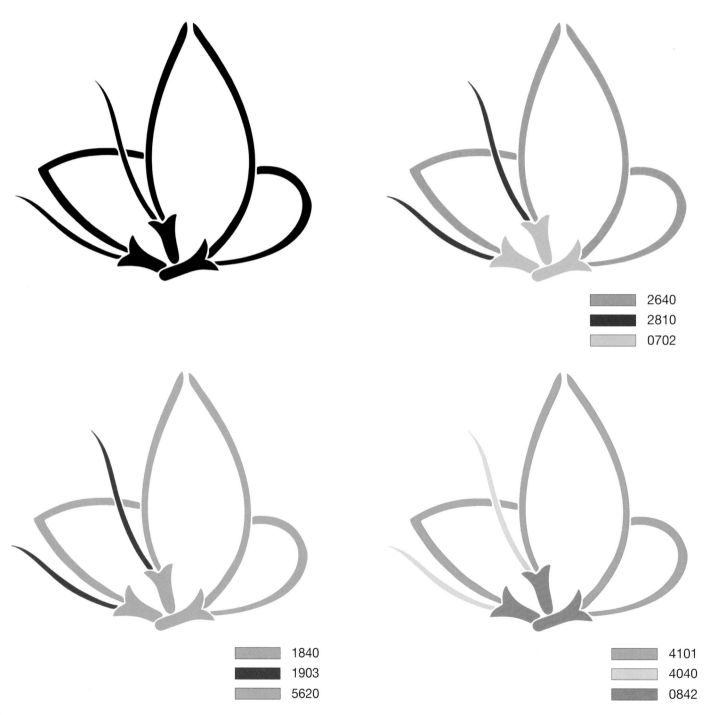

2640
2810
0702

1840
1903
5620

4101
4040
0842

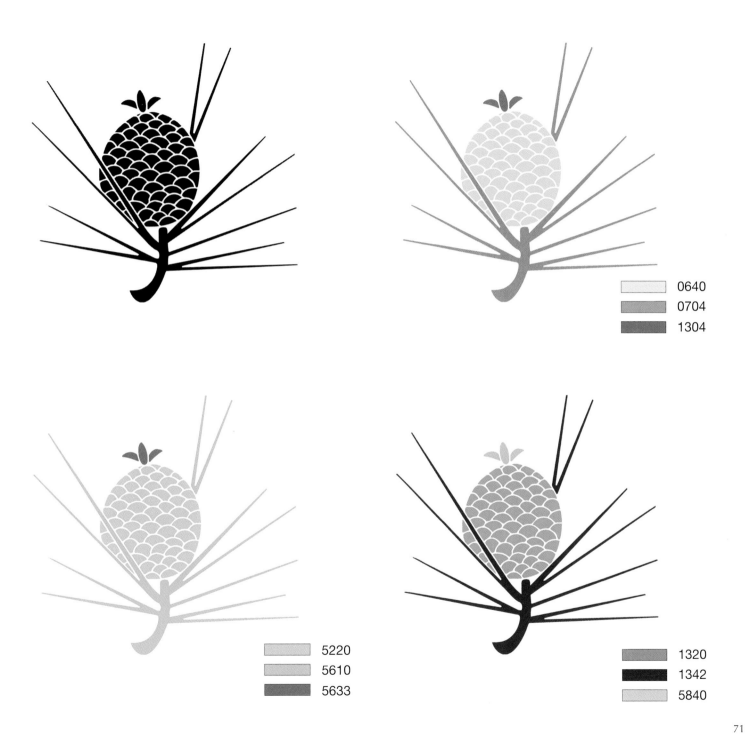

0640
0704
1304

5220
5610
5633

1320
1342
5840

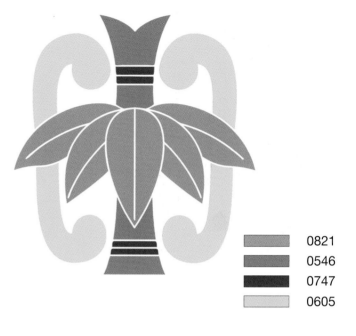

	0821
	0546
	0747
	0605

	5840
	4030
	2155
	3962

	5633
	3045
	6133
	6051

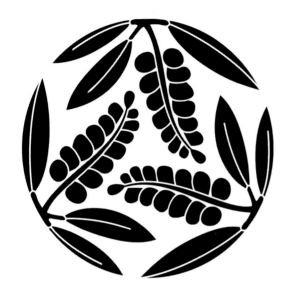

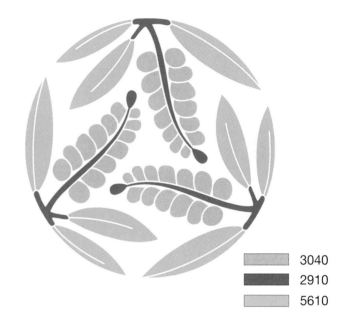

3040	
2910	
5610	

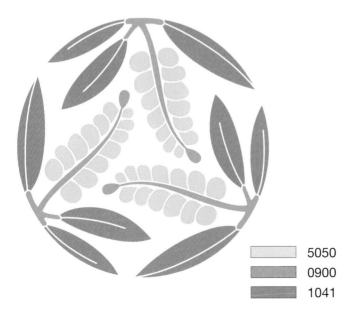

5050	
0900	
1041	

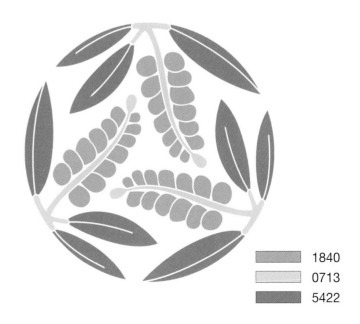

1840	
0713	
5422	

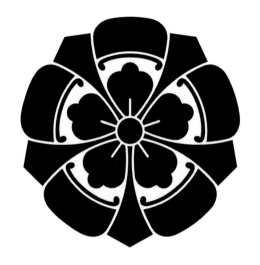

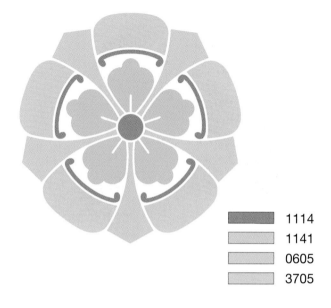

	1114
	1141
	0605
	3705

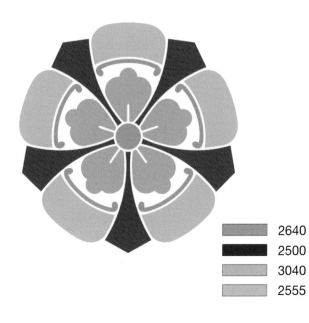

	2640
	2500
	3040
	2555

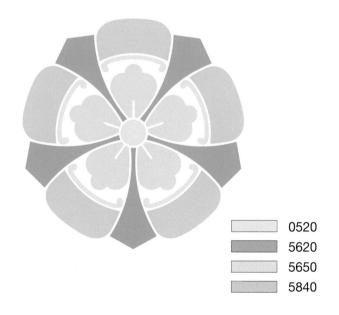

	0520
	5620
	5650
	5840

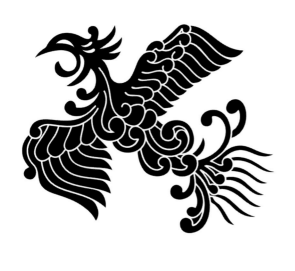

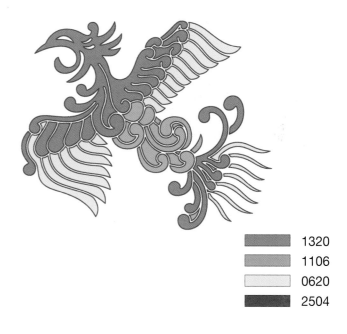

	1320
	1106
	0620
	2504

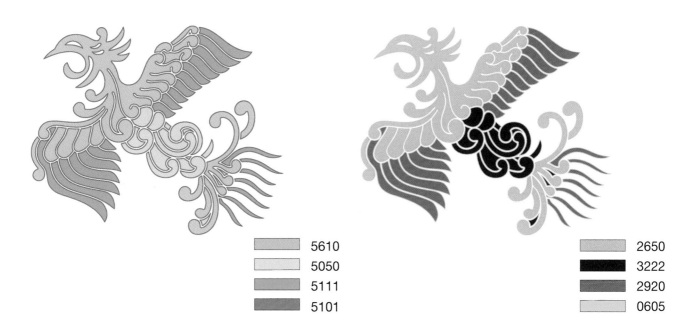

	5610
	5050
	5111
	5101

	2650
	3222
	2920
	0605

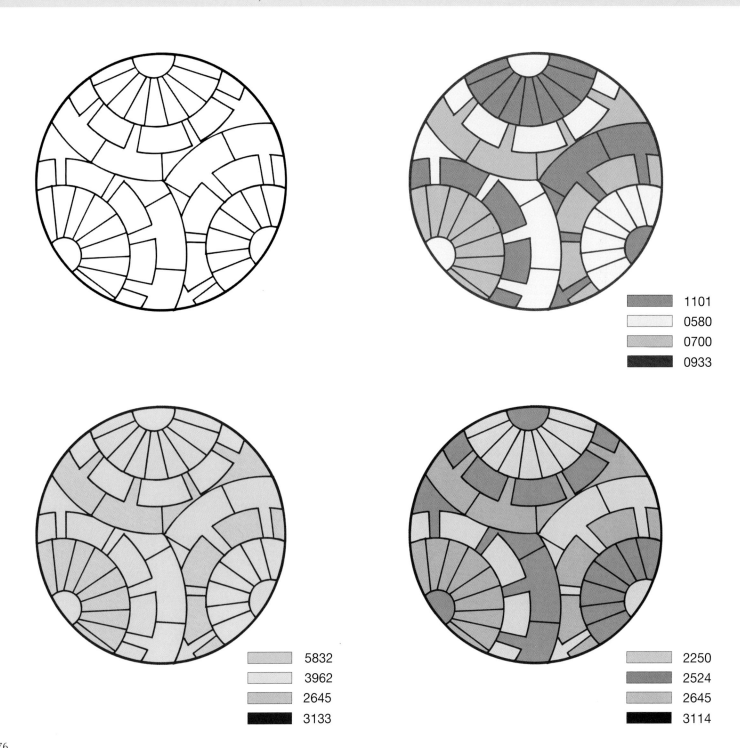

1101
0580
0700
0933

5832
3962
2645
3133

2250
2524
2645
3114

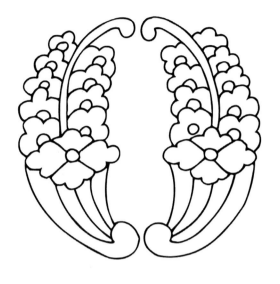
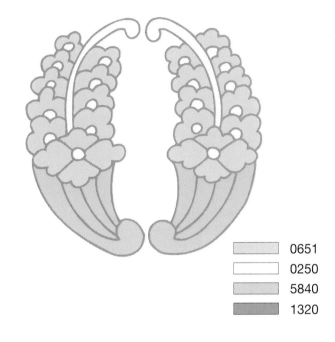

	0651
	0250
	5840
	1320

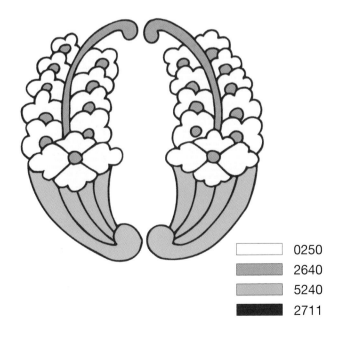
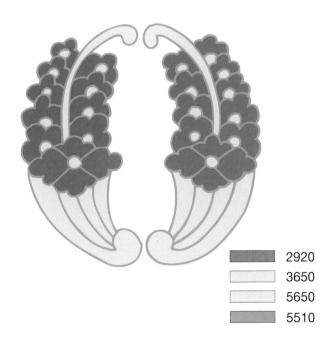

	0250
	2640
	5240
	2711

	2920
	3650
	5650
	5510

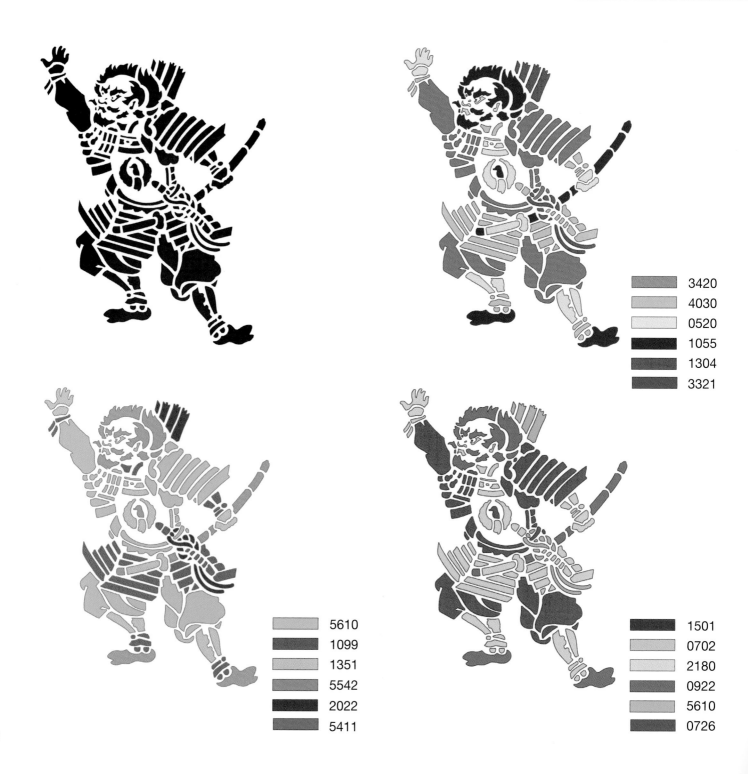

3420
4030
0520
1055
1304
3321

5610
1099
1351
5542
2022
5411

1501
0702
2180
0922
5610
0726

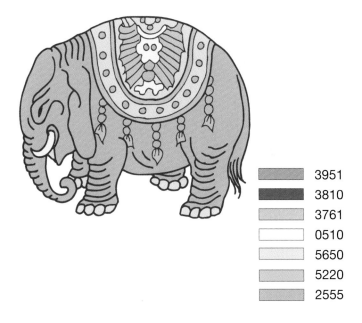

	3951
	3810
	3761
	0510
	5650
	5220
	2555

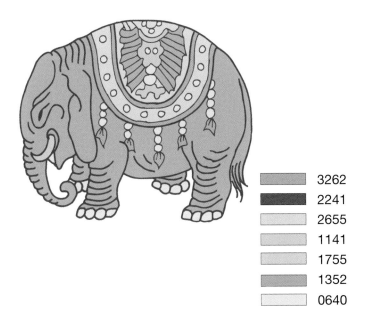

	3262
	2241
	2655
	1141
	1755
	1352
	0640

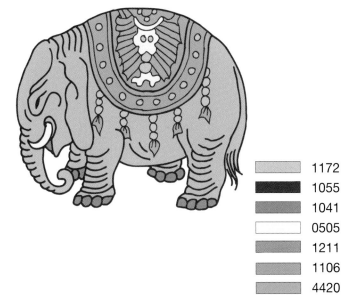

	1172
	1055
	1041
	0505
	1211
	1106
	4420

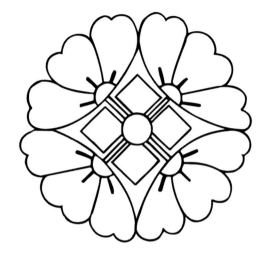

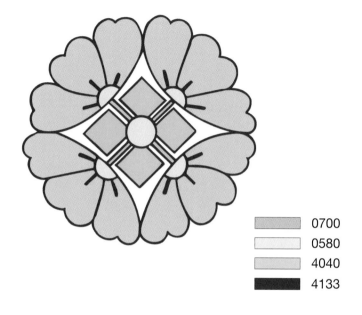

	0700
	0580
	4040
	4133

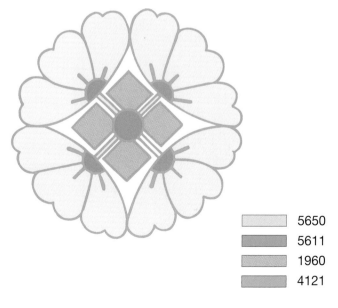

	5650
	5611
	1960
	4121

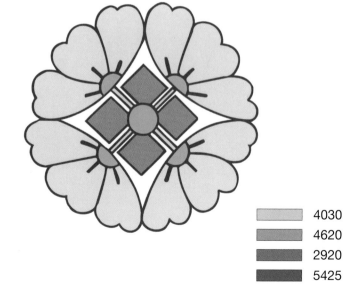

	4030
	4620
	2920
	5425

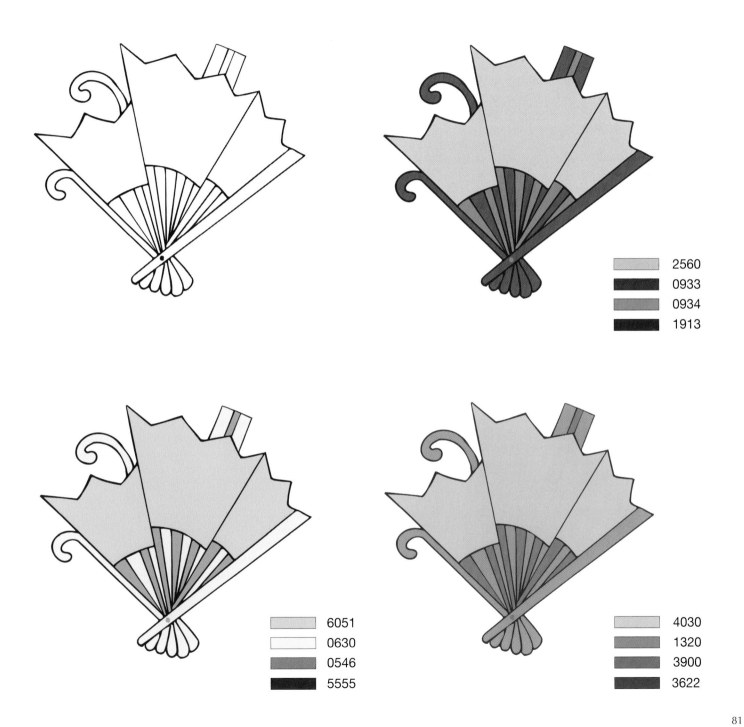

⬜	2560
⬛	0933
⬛	0934
⬛	1913

⬜	6051
⬜	0630
⬜	0546
⬛	5555

⬜	4030
⬜	1320
⬛	3900
⬛	3622

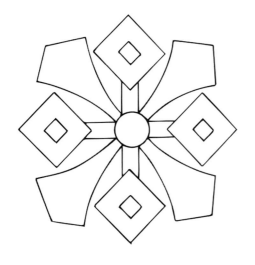

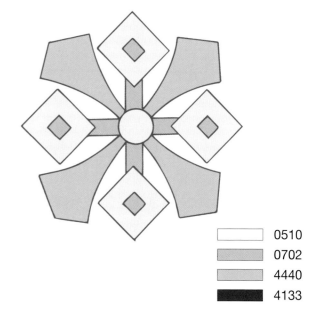

	0510
	0702
	4440
	4133

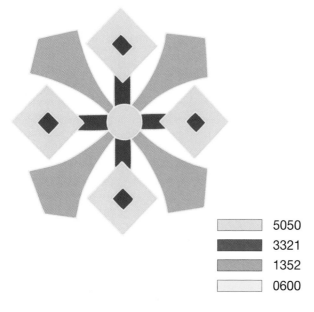

	5050
	3321
	1352
	0600

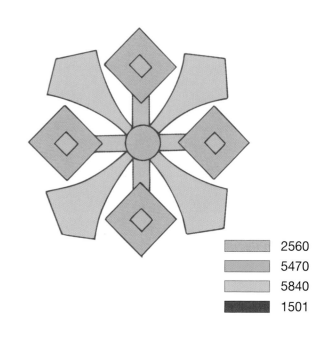

	2560
	5470
	5840
	1501

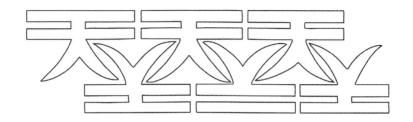

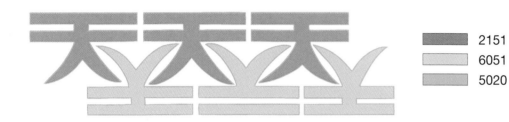

▬	2151
▭	6051
▬	5020

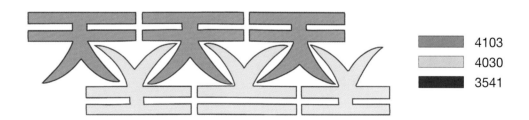

▬	4103
▭	4030
▬	3541

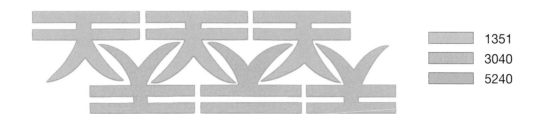

▭	1351
▬	3040
▬	5240

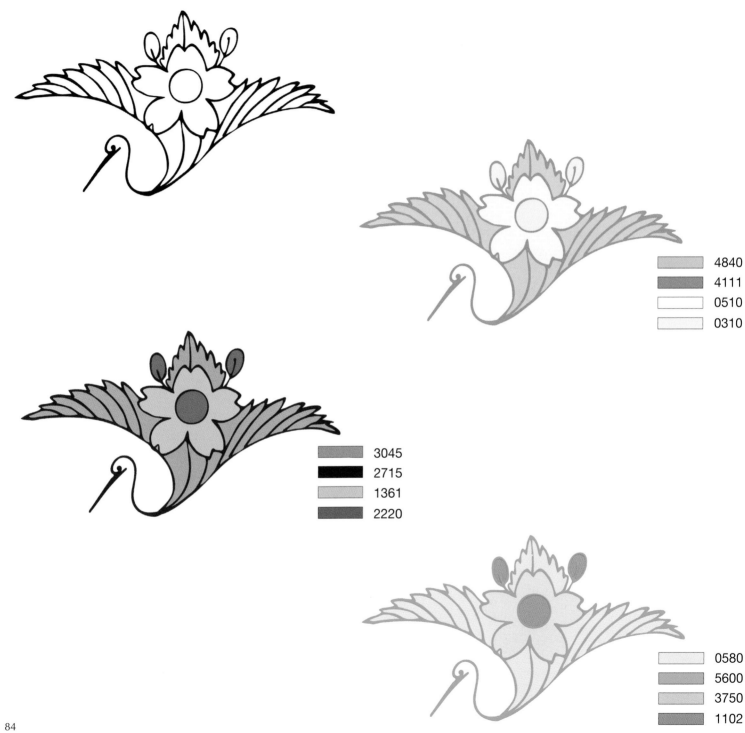

	4840
	4111
	0510
	0310

	3045
	2715
	1361
	2220

	0580
	5600
	3750
	1102

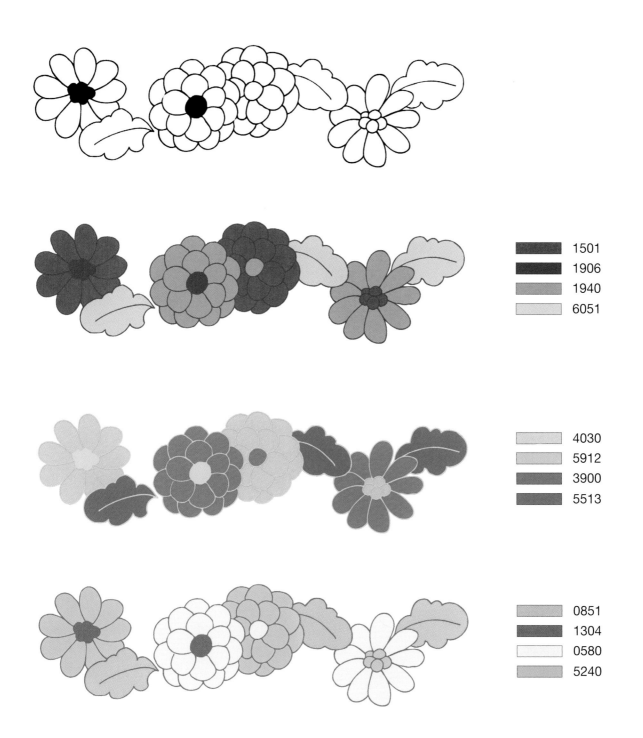

1501
1906
1940
6051

4030
5912
3900
5513

0851
1304
0580
5240

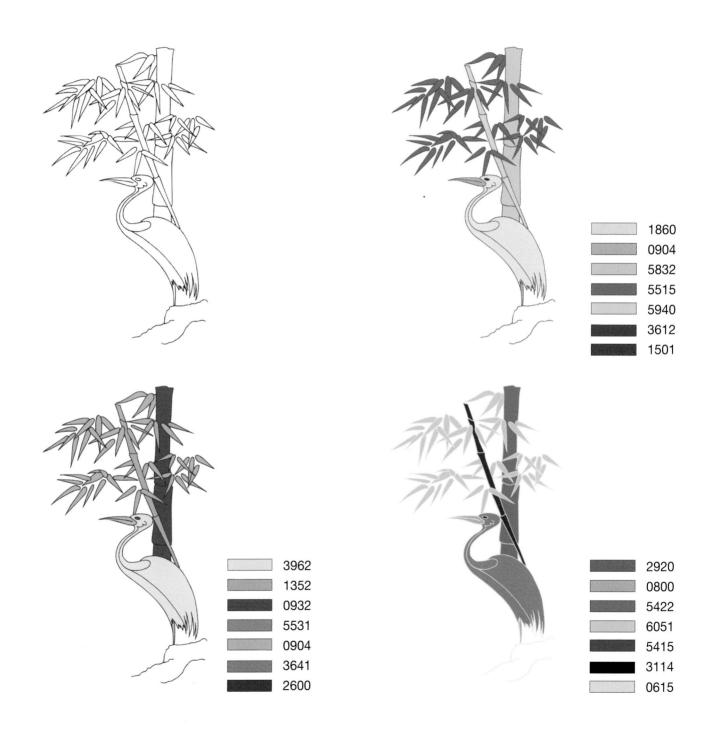

	1860
	0904
	5832
	5515
	5940
	3612
	1501

	3962
	1352
	0932
	5531
	0904
	3641
	2600

	2920
	0800
	5422
	6051
	5415
	3114
	0615

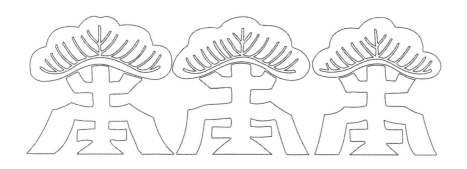

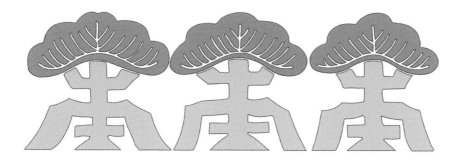

5611
5840
1300

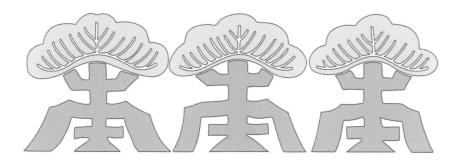

5940
5240
3213

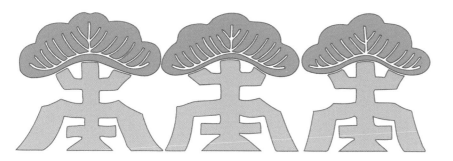

5210
0700
0842

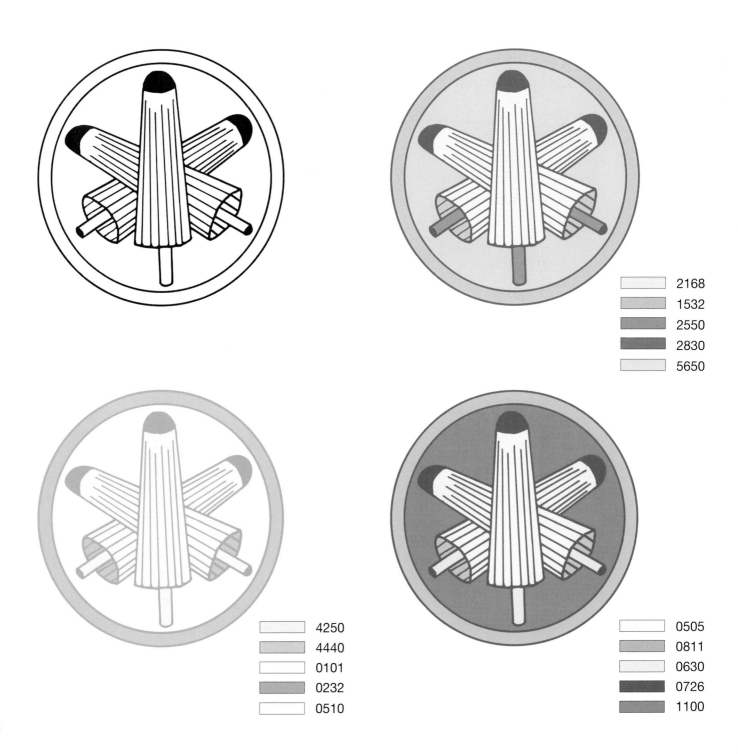

2168
1532
2550
2830
5650

4250
4440
0101
0232
0510

0505
0811
0630
0726
1100

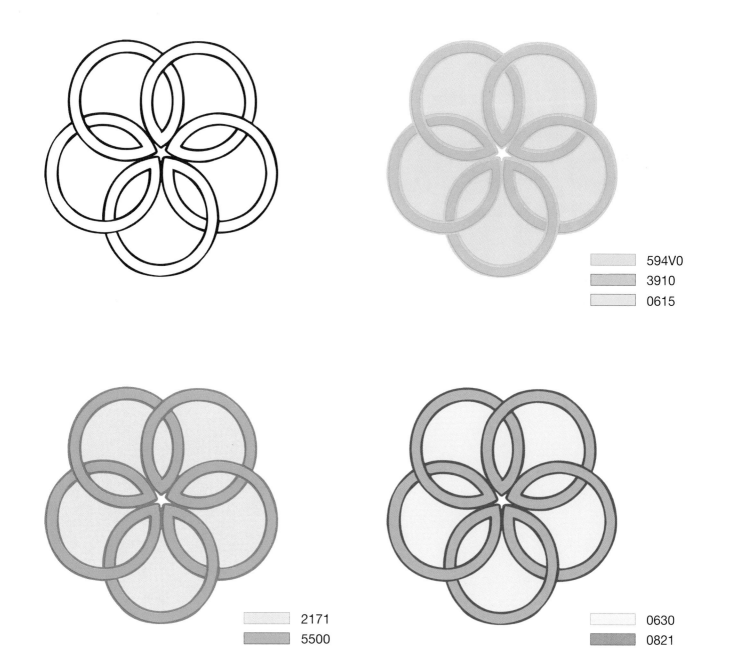

594V0
3910
0615

2171
5500
2220

0630
0821
2504

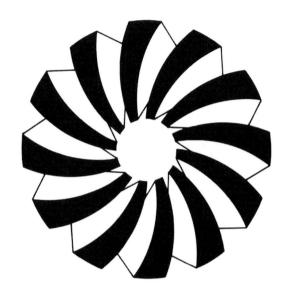

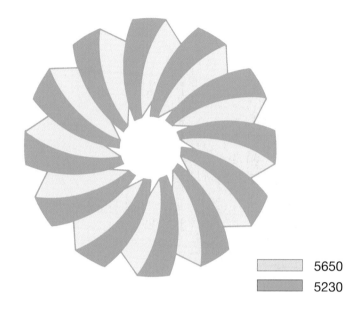

	5650
	5230

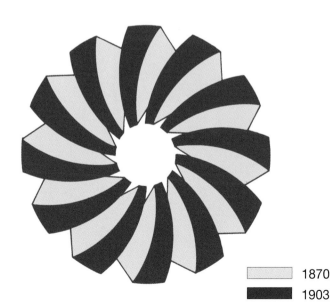

	1870
	1903

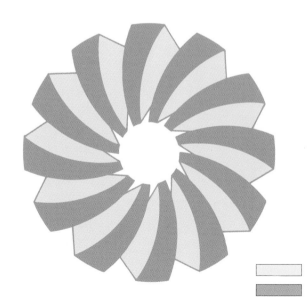

	0706
	0800

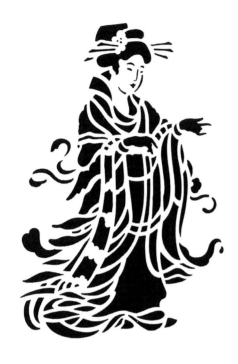

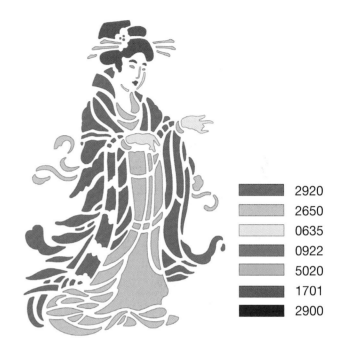

	2920
	2650
	0635
	0922
	5020
	1701
	2900

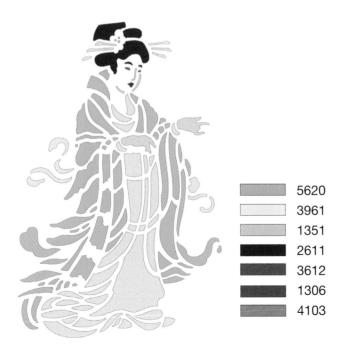

	5620
	3961
	1351
	2611
	3612
	1306
	4103

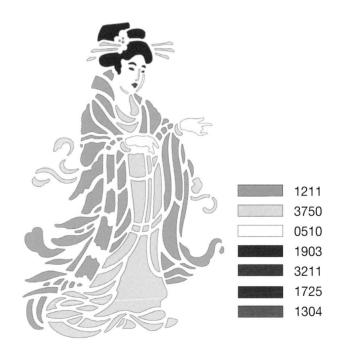

	1211
	3750
	0510
	1903
	3211
	1725
	1304

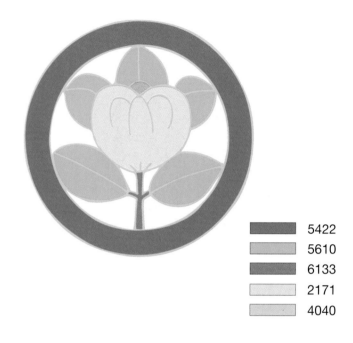

	5422
	5610
	6133
	2171
	4040

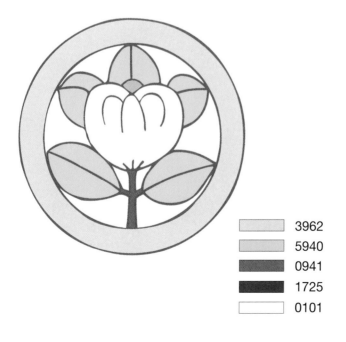

	3962
	5940
	0941
	1725
	0101

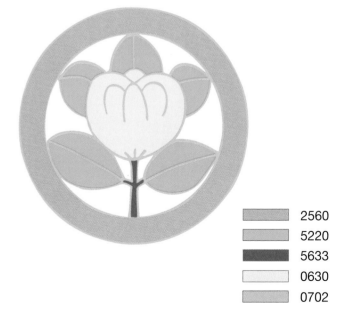

	2560
	5220
	5633
	0630
	0702

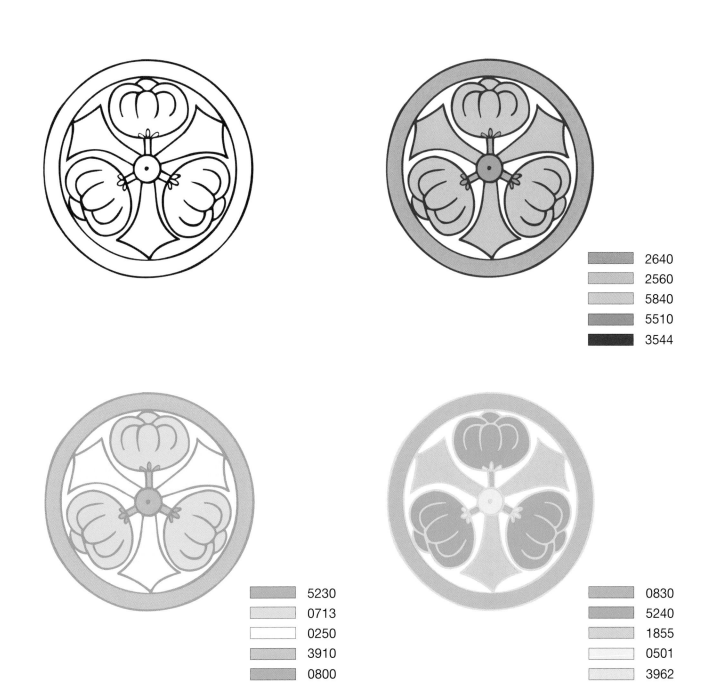

2640
2560
5840
5510
3544

5230
0713
0250
3910
0800

0830
5240
1855
0501
3962

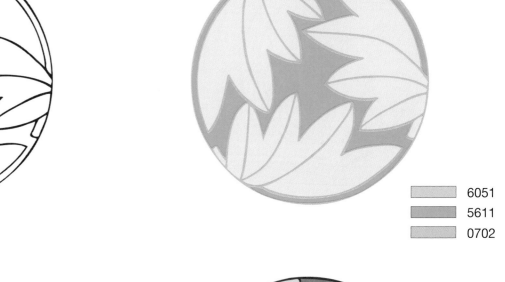

	6051
	5611
	0702

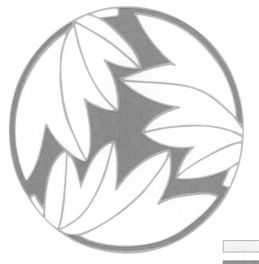

	0580
	1220
	5613

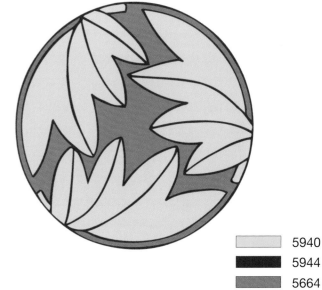

	5940
	5944
	5664

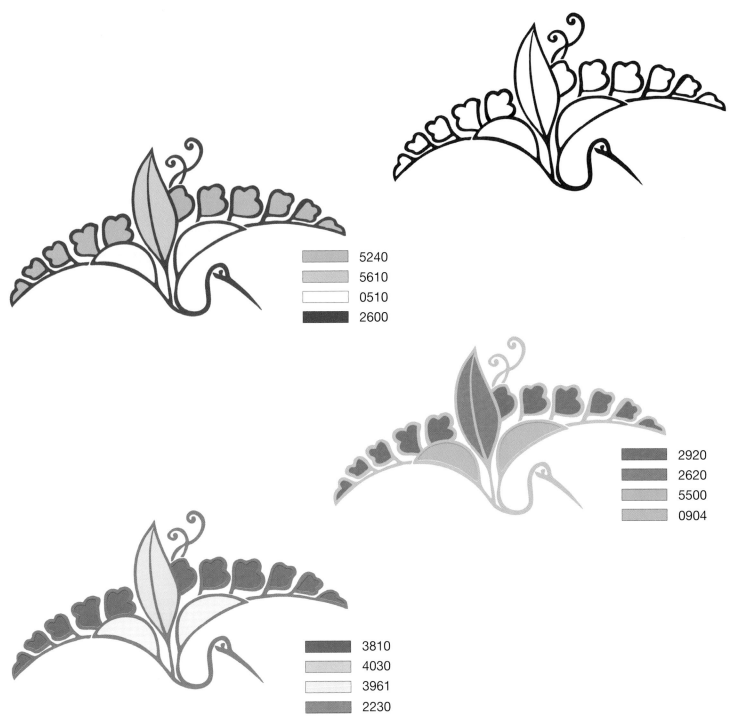

	5240
	5610
	0510
	2600

	2920
	2620
	5500
	0904

	3810
	4030
	3961
	2230

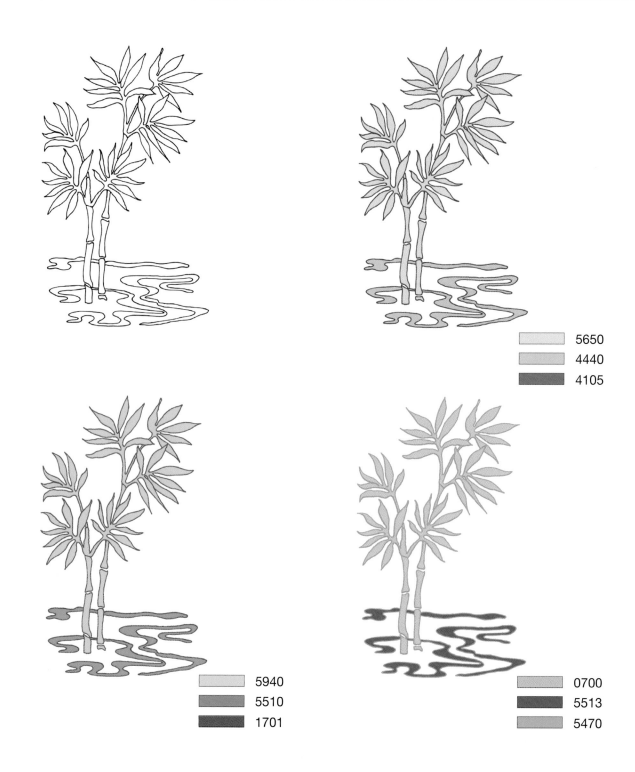

5650
4440
4105

5940
5510
1701

0700
5513
5470

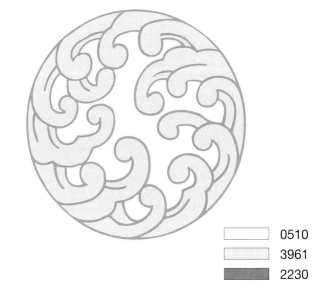

	0510
	3961
	2230

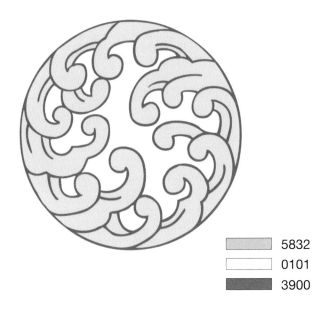

	5832
	0101
	3900

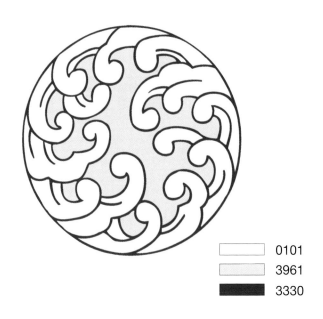

	0101
	3961
	3330

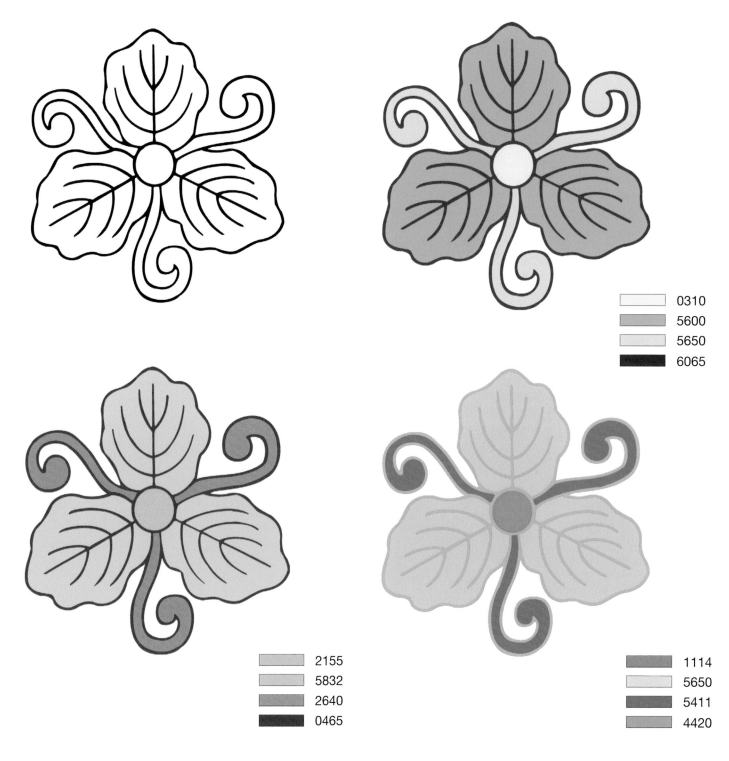

0310
5600
5650
6065

2155
5832
2640
0465

1114
5650
5411
4420

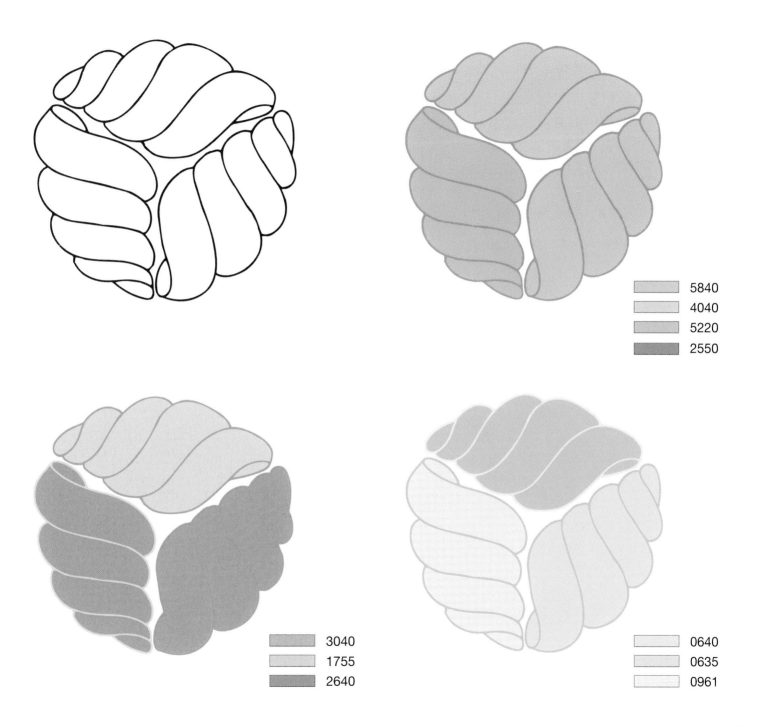

5840
4040
5220
2550

3040
1755
2640

0640
0635
0961

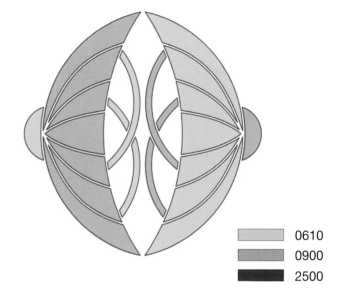

	0610
	0900
	2500

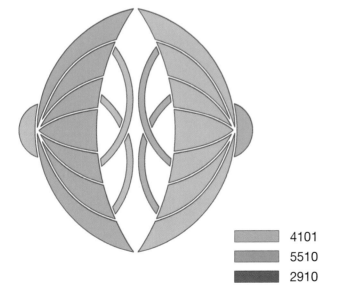

	4101
	5510
	2910

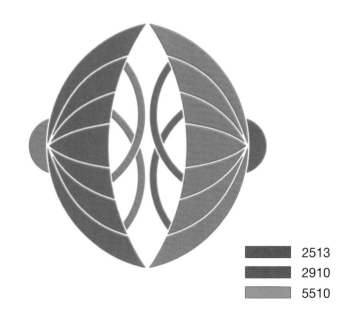

	2513
	2910
	5510

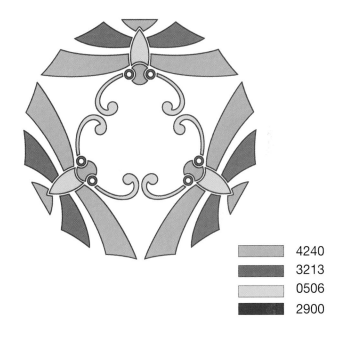

	4240
	3213
	0506
	2900

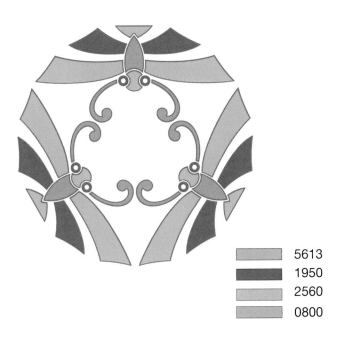

	5613
	1950
	2560
	0800

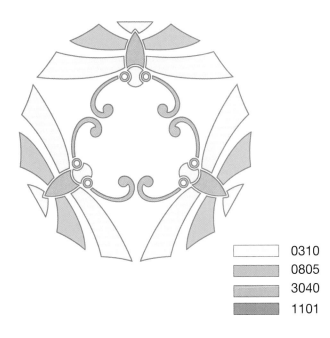

	0310
	0805
	3040
	1101

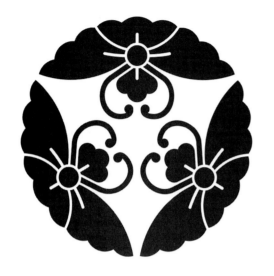

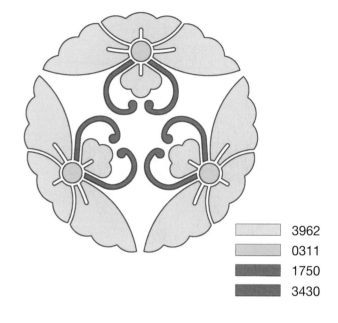

	3962
	0311
	1750
	3430

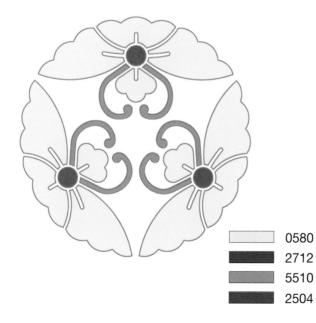

	0580
	2712
	5510
	2504

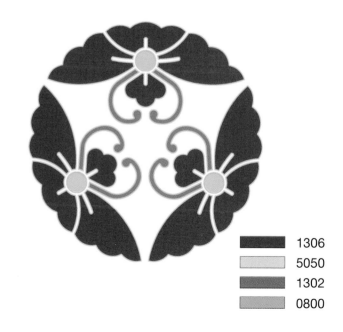

	1306
	5050
	1302
	0800

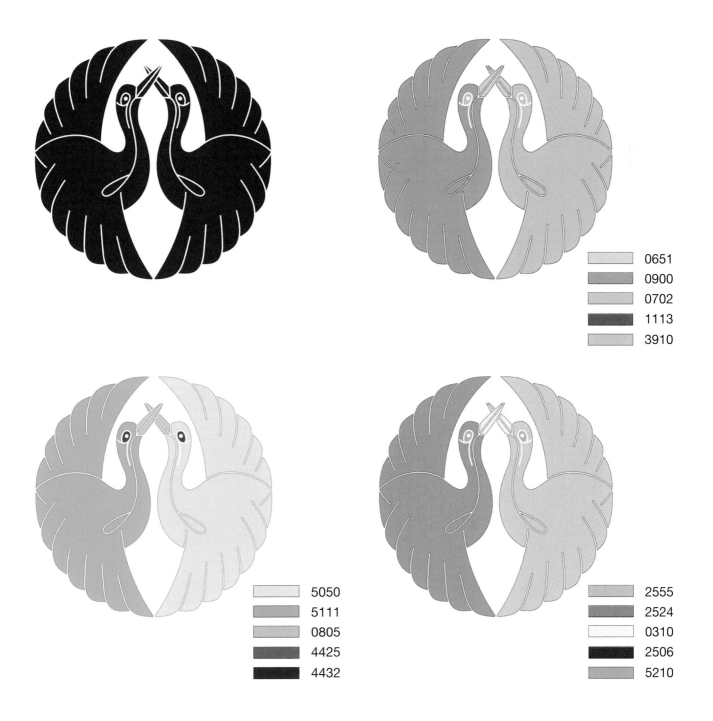

	0651
	0900
	0702
	1113
	3910

	5050
	5111
	0805
	4425
	4432

	2555
	2524
	0310
	2506
	5210

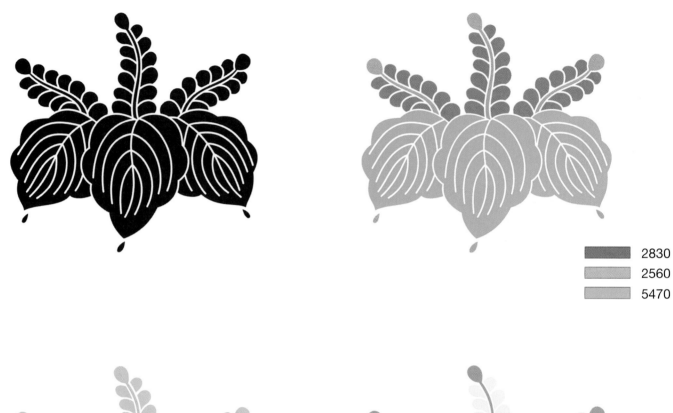

2830
2560
5470

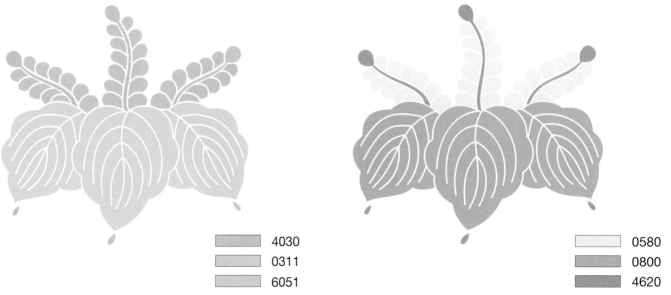

4030
0311
6051

0580
0800
4620

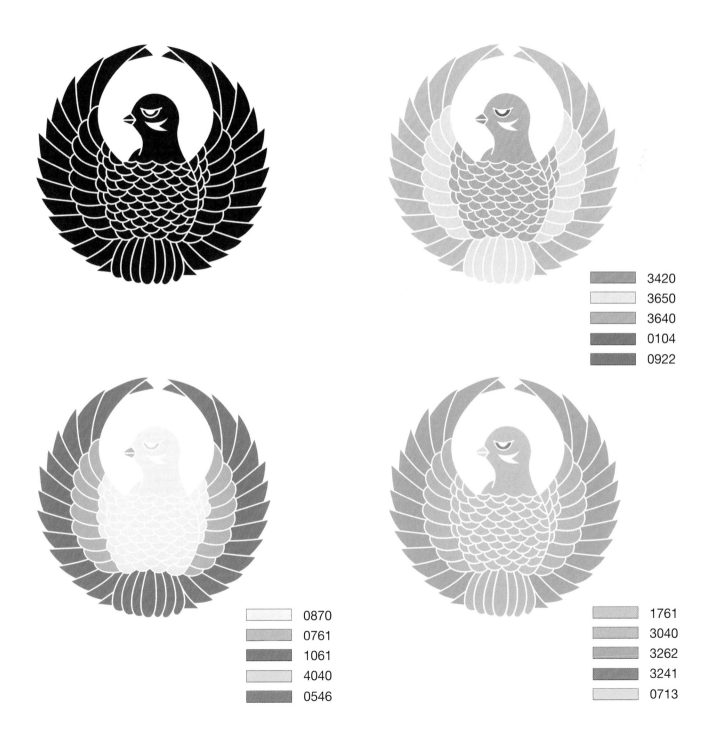

3420
3650
3640
0104
0922

0870
0761
1061
4040
0546

1761
3040
3262
3241
0713

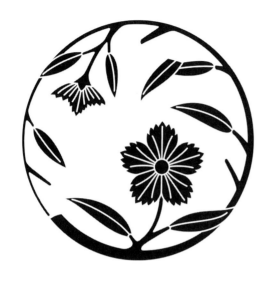

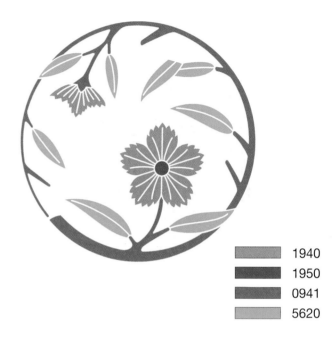

	1940
	1950
	0941
	5620

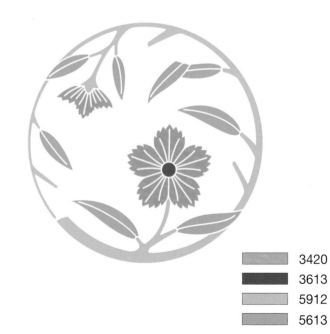

	0580
	0610
	5050
	5510

	3420
	3613
	5912
	5613

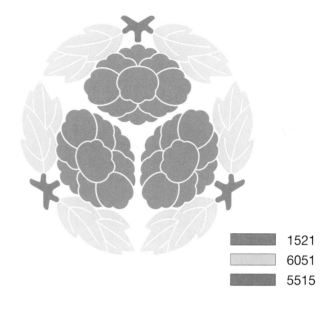

	1521
	6051
	5515

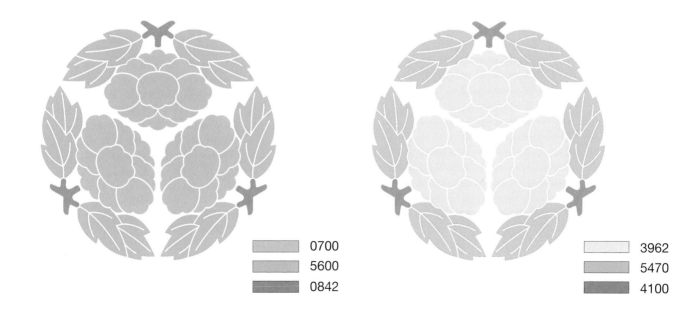

	0700
	5600
	0842

	3962
	5470
	4100

Isacord-To-Other Thread Color Equivalents

ISACORD®	SULKY®	MADEIRA®	METTLER®
0010	1001	1001	0010
0015	1002	1071	0015
0017	1001	1001	0015
0020	1234	1000	0020
0101	1071	1071	0101
0108	1219	1118	0108
0111	1041	1241	0111
0112	1220	1041	0112
0124	1236	1087	0124
0131	1219	1118	0131
0132	1120	1041	0132
0142	1011	1118	0142
0145	1011	1087	0145
0150	1218	1087	0150
0151	1085	1062	0151
0152	1219	1118	0152
0180	1120	1087	0182
0182	1236	1087	0182
0184	1218	1060	0182
0221	1067	1223	0221
0232	1127	1106	0232
0250	1022	1067	0250
0270	1061	1067	0670
0310	1067	1223	0310
0311	1124	1024	0311
0345	1156	1157	0345
0352	1209	1106	0352
0442	1227	1190	0542
0453	1128	1306	0453
0463	1228	1306	0873
0465	1173	1357	0465
0501	✿	✿	0501
0506	1124	1024	0700
0520	1135	1023	0520
0532	1070	1070	0532
0542	1159	1192	0542
0546	1159	1192	0542
0552	1055	1055	0552
0600	1187	1223	0600
0605	1124	1372	0600
0608	1023	1223	0311
0630	1135	1023	0630
0640	1066	1372	0640
0651	1149	1055	0651
0660	1061	1067	0660
0670	1071	1071	0670
0672	1229	1060	0672
0700	1024	1024	0700
0702	1024	1024	0702
0704	1085	1025	0704
0706	✿	✿	0706
0713	1167	1372	0713
0722	1179	1128	0722
0747	1173	1157	0747
0761	1127	1055	0761
0776	1180	1062	0776
0800	1024	1137	0800
0811	1024	1372	0811
0821	1025	1025	0811
0822	1070	1070	0822
0824	1025	1173	0940
0832	1055	1126	0832
0842	1126	1126	0842
0851	1055	1055	0651
0853	1170	1144	0853
0861	1127	1060	0672
0862	1128	1128	0672
0870	1082	1082	0870
0873	1180	1062	0873
0874	1179	1062	0874
0904	1065	1137	0922*
0922	1025	1173	0922
0931	1158	1173	0932
0932	1126	1773	0932
0933	1057	1173	0933
0934	1128	1173	0934
0940	1026	1128	0940
0941	1126	1173	0941
0945	1170	1144	0945
0970	1071	1067	0970
1055	1179	1053	1055
1060	1017	1145	1060
1061	1179	1142	1061
1102	1168	1278	1102
1106	✿	✿	1106
1114	1021	1065	1114
1115	1216	1057	1342
1120	✿	✿	1120
1123	1128	1128	0853
1134	1158	1057	1134
1140	1017	1055	1140
1141	1054	1142	1141
1154	1158	1057	0933
1172	1149	1055	1172
1220	1238	1379	1220
1300	1078	1278	1300
1301	1078	1037	1304
1304	1078	1078	1304
1305	1184	1379	1305
1306	✿	✿	1306
1311	1216	1221	1334
1312	1181	1221	1514
1332	1021	1379	1114
1334	1181	1221	1334
1335	1181	1221	1335
1342	1058	1057	1342
1346	1247	1145	1346
1351	1019	1019	1351

ISACORD®	SULKY®	MADEIRA®	METTLER®
1352	1258	1019	1352
1355	1186	1145	1355
1362	1239	1019	1362
1366	1215	1059	1366
1375	1131	1041	1375
1430	1019	1019	1430
1501	☼	☼	1306
1514	1181	1221	1334
1521	1020	1379	1521
1532	1020	1107	1532
1551	1019	1019	1551
1565	1179	1144	1565
1600	1081	1379	1600
1701	1246	1078	1703
1703	1037	1037	1703
1704	1037	1037	1703
1725	1181	1221	1725
1755	1117	1019	1755
1760	1064	1142	1760
1761	1015	1142	1761
1800	1147	1037	1703
1805	1259	1147	1805
1840	1016	1107	1840
1860	1015	1019	1860
1874	1130	1062	1375
1876	1059	1145	1876
1900	1039	1147	1900
1902	1147	1147	1902
1903	1147	1147	1903
1904	1147	1039	1903
1906	1533	1186	1900
1911	1169	1181	1911
1912	1035	1181	1912
1913	1169	1181	1911
1921	1257	1119	1921
1940	☼	☼	1940
1950	☼	☼	1950
1972	1219	1118	1972
2011	1169	1181	1911
2022	1090	1181	1912
2051	1213	1019	2051
2101	1039	1147	1900
2113	1035	1181	2113
2115	1035	1181	2222
2123	1189	1035	2123
2152	1119	1108	2152
2153	1119	1108	2152
2155	1115	1108	2155
2160	1115	1116	2160
2166	1117	1019	2160
2170	1064	1053	2170
2171	1113	1120	2171
2220	1511	1309	2220
2222	1169	1117	2222
2224	1190	1181	2222
2241	1119	1119	2241
2250	1225	1120	2250
2300	1231	1110	2300
2320	1511	1119	2320
2333	1038	1035	2222
2336	1189	1035	2336
2363	1121	1120	2360
2500	1192	1188	2500
2504	1033	1188	2504
2506	1192	1188	2506
2520	1511	1110	2520
2521	1533	1186	2521
2550	1256	1309	2550
2560	1224	1108	2560
2576	1166	1041	0112
2600	1255	1033	2600
2640	1080	1080	2640
2674	1166	1041	2674
2711	1192	1188	2711
2715	1192	1188	2715
2720	1033	1188	2504
2764	1111	1031	2664
2810	1255	1122	2810
2830	1032	1032	2830
2900	1112	1112	2900
2905	1122	1112	2900
2910	1032	1032	2900
2920	1194	1032	2920
3040	1193	1032	3040
3045	1080	1080	3040
3062	1166	1040	3062
3102	1197	1166	3102
3110	1195	1166	3110
3114	1195	1122	3110
3210	1235	1143	3210
3211	1235	1112	3211
3241	1254	1032	3241
3251	1193	1040	3241
3323	1200	1242	3323
3331	1226	1143	3331
3333	1042	1166	3333
3335	1535	1134	3544
3344	1182	1044	3355
3353	1197	1242	3323
3355	1043	1044	3355
3444	1172	1044	3444
3522	1076	1134	3522
3536	1195	1122	3536
3541	1112	1112	3541
3543	1042	1134	3543
3544	1535	1134	3544
3554	1044	1044	3355
3600	1535	1134	3600

Isacord-To-Other Thread Color Equivalents

ISACORD®	SULKY®	MADEIRA®	METTLER®
3611	1535	1134	3543*
3612	1253	1133	3543*
3622	1076	1134	3622
3640	1030	1075	3640
3641	1198	1028	3641
3650	1074	1132	3650
3652	1222	1132	3640*
3732	1198	1143	3732
3743	1171	1143	3743
3750	1165	1132	3750
3761	1165	1132	3761
3770	1077	1087	3770
3810	1143	1143	3810
3815	1029	1028	3641*
3820	1028	1028	3820
3840	1222	1132	3840
3842	1172	1028	3842
3900	1534	1096	3900
3901	1534	1295	3901
3902	1253	1177	3901*
3910	1249	1028	3910
3951	1203	1028	3951
3953	1172	1028	3953
3962	1248	1132	3962
3971	1236	1087	3971
4010	1094	1094	4010
4032	1172	1028	4032
4033	1171	1293	4033
4071	1223	1132	3952
4073	1219	1118	0108*
4101	1094	1094	4101
4103	1252	1295	4103
4111	1094	1094	4111
4113	1252	1295	4111*
4116	1252	1295	4116
4133	1162	1296	3732*
4174	1234	1241	4174
4220	1095	1045	4220
4230	1204	1094	4230
4240	1204	1045	4240
4250	1151	1045	4250
4410	1513	1293	4610*
4421	1090	1293	4531*
4423	1513	1295	4423
4425	1230	1293	4531*
4430	1095	1045	4220*
4442	1162	1293	4442
4452	1090	1279	4531*
4515	1162	1290	4515
4531	1513	1293	4531
4610	1046	1279	4610
4620	1046	1279	4620
4625	1230	1279	5005*
4643	1233	1290	4643
4644	1233	1290	4644
5005	1517	1280	5005
5010	1503	1247	5101*
5050	1045	1045	5050
5100	1503	1280	5100
5101	1503	1280	5101
5115	1046	1301	5115
5210	1503	1301	5210
5220	1045	1301	5220
5230	1045	1301	5230
5233	1517	1279	5324*
5324	1174	1103	5324
5326	1174	1370	5326
5335	1517	1370	5324
5374	1536	1103	5374
5411	1101	1051	5515
5415	1101	1051	5415
5422	1079	1051	5422
5500	✧	✧	5500
5510	1049	1101	5510
5513	1049	1101	5513
5515	1101	1051	5515
5531	1049	1101	5531
5552	1211	1306	5552
5555	1174	1103	5555
5610	1510	1248	5610
5613	1101	1101	5600
5633	1176	1170	5633
5643	1176	1170	5643
5650	1209	1100	5650
5664	1212	1306	5664
5822	1104	1106	5822
5833	1177	1170	5833
5866	1210	1357	0465
5912	1510	1248	5912
5933	1176	1170	5633*
5934	1176	1156	5934
5940	✧	✧	5940
5944	1175	1103	5944
6010	✧	✧	5940*
6051	1104	1100	6051
6133	1227	1190	6133
6156	1210	1357	6156

Isacord® is distributed by Brewer Quilting & Sewing Supplies to local embroidery dealers.

Isacord® is a registered trademark of Ackermann, a division of the Amann Group.

Sulky® is a registered trademark of Sulky of America.

Madeira® is a registered trademark of Madeira USA LTD.

Mettler® is a registered trademark of Mettler.

Resources

General Machine Embroidery Information:

http://sewing.about.com/od/machineembroidery/bb/embroidery.htm

http://en.wikipedia.org/wiki/Machine_embroidery

Design-making Software Programs:

Amazing Designs Digitize 'N Stitch	https://www.amazingdesigns.com/en/products/embroidery-software
Fancyworks Studio / Digitizing Software	http://www.creativeseries.com/cs2_fancyworksstudio.asp
Digitizing Pro III	http://www.florianisoftware.com/products///6876
Embroidery Suite Pro 2008	http://www.florianisoftware.com/products/*/*/11
Buzz Tools	http://www.buzztools.com/embroidery_menu.asp
Embroidery Software V6	http://www.berninausa.com/product_overview-n6-sUS.html
Drawings 4	http://www.drawstitch.com/DRAWings4.htm
Embroidery Office Design Maxx	http://www.embroideryoffice.com/art-d50.htm
Ricoma D.I.S.C	http://www.ricoma.us/disc_software.cfm
Brother PE Design	http://www.brother-usa.com/HomeSewing/software/default.aspx
Compucon Creator Plus	http://www.compuconusa.com/creator_plus.htm
EMBird Suite	http://www.embird.com
Mad Punch	http://www.madpunch.com
ThredWorks	http://www.thredworks.com

Embroidery Machines and Supplies:

http://www.allbrands.com/products/abc0147.html

http://www.icanhelpsew.com

http://www.stitch.com

http://www.embroidery.com

http://www.sewingmachinesplus.com

Resources, continued.

Video Instruction:

http://www.youtube.com, search by 'machine embroidery'

http://www.astitchclub.com/cat-machine-embroidery-video-tutorials.cfm

Magazines:

Creative Machine Embroidery	http://www.cmemag.com
Threads	http://www.threadsmagazine.com
Designs in Machine Embroidery	http://www.dzgns.com
Sew News	http://www.sewnews.com

Embroidery Sewing Machines Reviews:

http://www.consumersearch.com/sewing-machines/embroidery-machines

http://www.sewingmachinereviewer.com/embroidery-machines.html